W9-BZF-079

Let's Draw Manga

NINJA & SAMURAI

By Hidefumi Okuma

DIGITAL MANGA PUBLISHING

Carson

Illustration:	HIDEFUMI OKUMA
Composition:	KEN SASAHARA
Cover Art:	ALAN WAN
Translation:	FAIZI PARKES
English Editing:	NEIL GARSCADDEN
Layout:	GEN ISHO, INC.
Editing Assistant:	TRISHA KUNIMOTO
Publisher:	HIKARU SASAHARA
Japan Relations:	JOHN WHALEN
Print Production Manager	FRED LUI

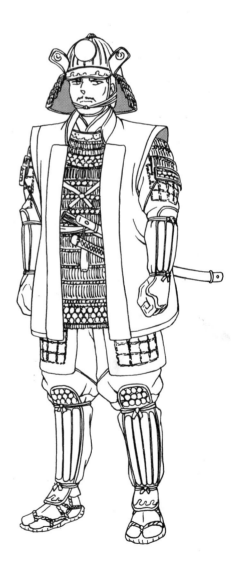

LET'S DRAW MANGA
Ninja & Samurai

English Edition Published by
DIGITAL MANGA PUBLISHING
1123 Dominguez Street, Unit K
Carson, CA 90746
www.emanga.com
tel: (310) 604-9701
fax: (310) 604-1134

Distributed Exclusively in North America by
WATSON-GUPTILL PUBLICATIONS
a division of VNU Business Media
770 Broadway, New York, NY 10003
www.watsonguptill.com

ISBN: 1-56970-990-4
Library of Congress Control Number: 2003095713
First Edition January 2004
10 9 8 7 6 5 4 3 2 1

Printed in China

Contents

Aim of this book

Japan's historic characters, the ninja and samurai, are unique in their shape. A look at historic documents reveals the shape of these characters to be very simple, dynamic and rational. While this book faithfully reflects history, it also incorporates many of the popular action illustrations of today. Characters that are difficult to draw are shown from various angles to aid comprehension and drawings are arranged to enable any skill level to grasp their verities. In compiling this book it became apparent that the world of the samurai and ninja is a deep one indeed; and the simple, dynamic and rational nature of these characters, as stated before, also finds itself manifest in their ideals and lifestyle. Through television, movies and comics, ninja and samurai have aroused the interest of people around the world, which is indicative of the universal appeal of Japan's historic characters. A single book cannot cover this topic as thoroughly as we would like, and so a further effort is hoped for. We hope this book serves to assist you in furthering your drawing skills.

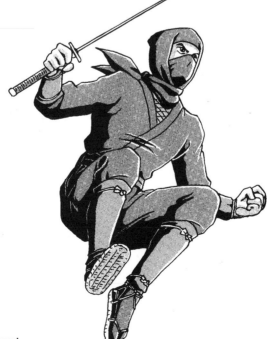

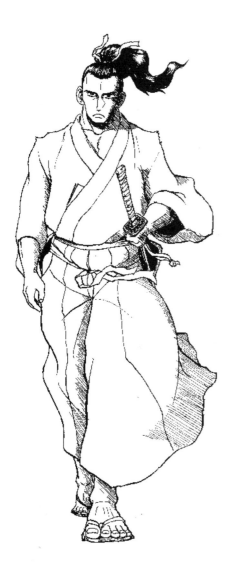

侍

Chapter 1
Drawing samurai

Samurai attire

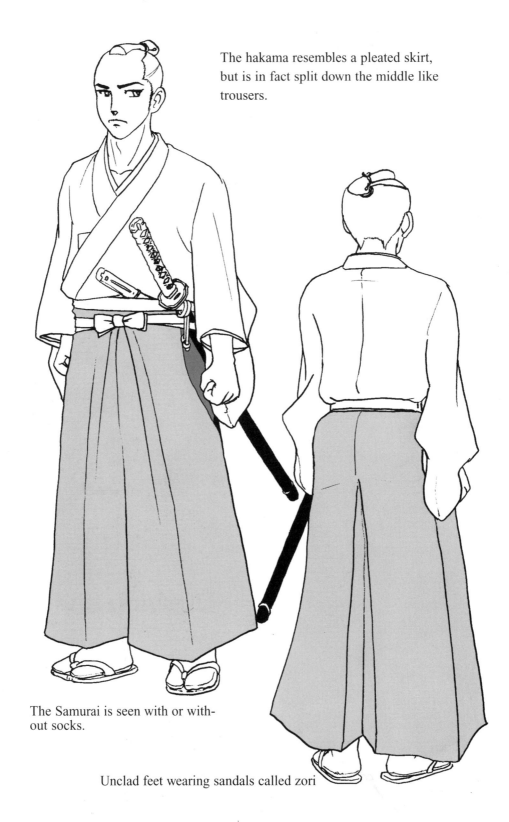

The hakama resembles a pleated skirt, but is in fact split down the middle like trousers.

The Samurai is seen with or without socks.

Unclad feet wearing sandals called zori

Samurai attire

Here's a look at a samurai from a different angle. The obi (belt) keeps the long and short swords in place. The swords are normally drawn tucked into the belt on the left hand side.

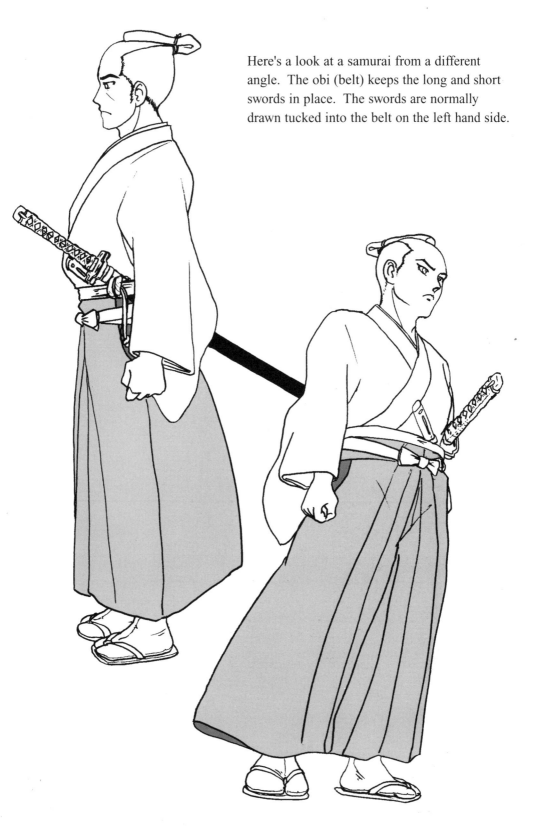

Drawing samurai

Facial close-up

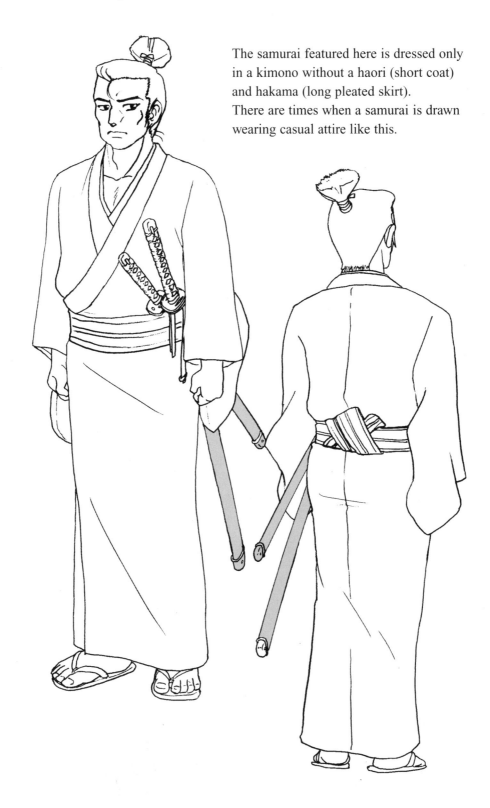

The samurai featured here is dressed only in a kimono without a haori (short coat) and hakama (long pleated skirt).

There are times when a samurai is drawn wearing casual attire like this.

Samurai attire (1)

This style of clothing is often used for outlaws. This figure is carrying two long swords.

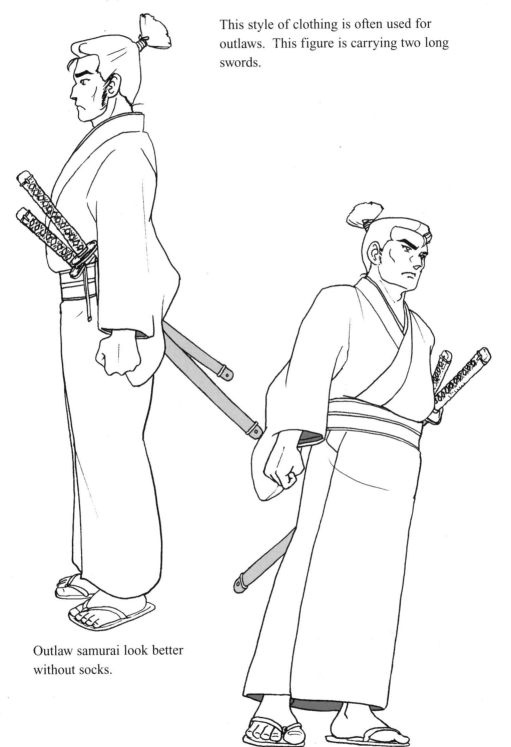

Outlaw samurai look better without socks.

Facial close-up

Topknot-chonmage-shape (1)

This is a close-up of the head and hair of a samurai. The upper forehead is completely shaved in a style called sakayaki.
The remaining hair is grown and then tied and folded back onto the top of the head.

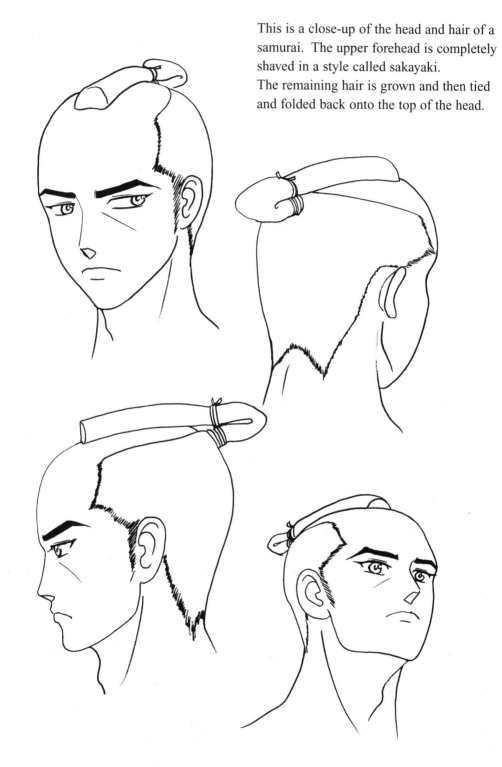

Topknot-chonmage-shape (2)

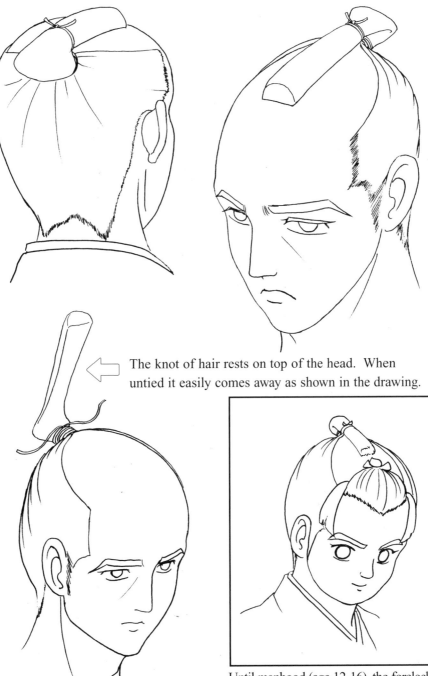

The knot of hair rests on top of the head. When untied it easily comes away as shown in the drawing.

Until manhood (age 12-16), the forelocks are left unshaved.

Drawing the topknot

Topknot-chonmage-shape (3)

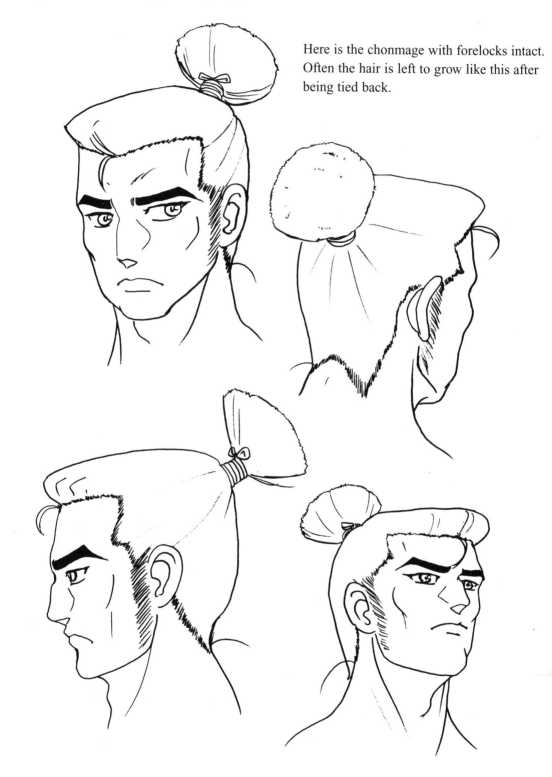

Here is the chonmage with forelocks intact. Often the hair is left to grow like this after being tied back.

Drawing the topknot

Various styles of topknots (4)

Tied back hair characterizes the chonmage. Depending on the length of the hair most of it is usually swept back and tied together.

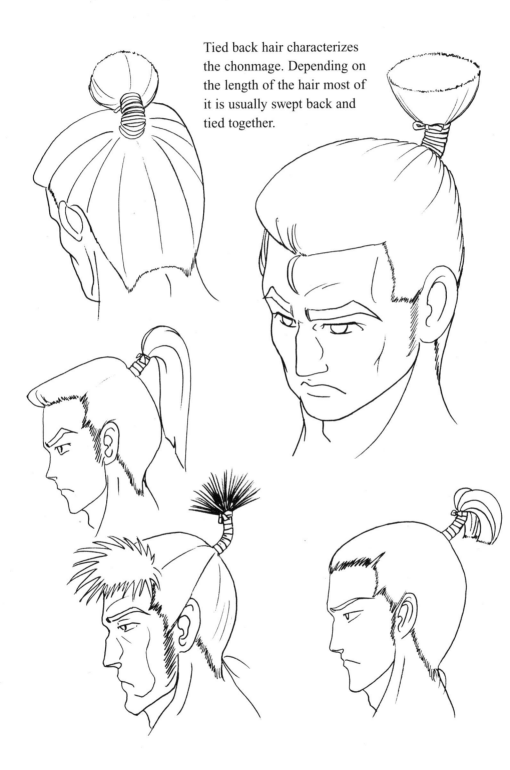

Battle-readied samurai

When heading into a full-scale battle, samurai wore more armor for protection. This picture shows the yoroi (body armor) and kabuto (helmet) that they wore.

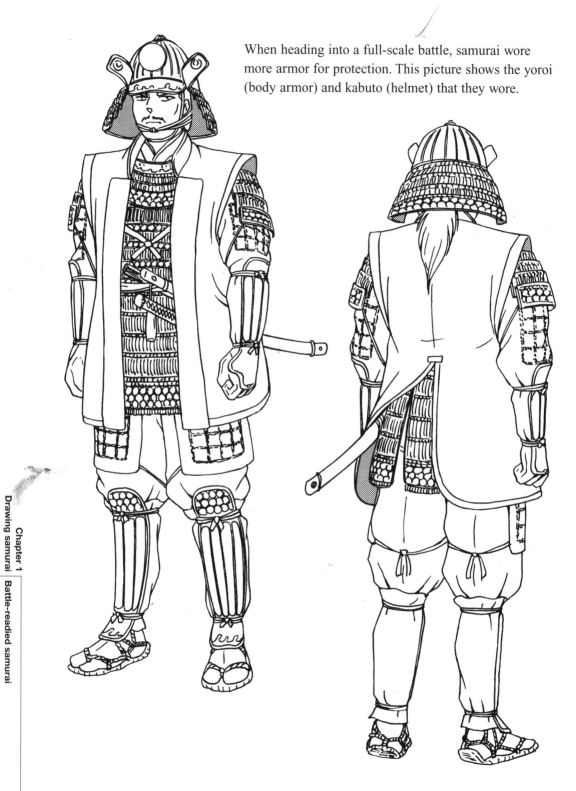

The body armor seen from different angles

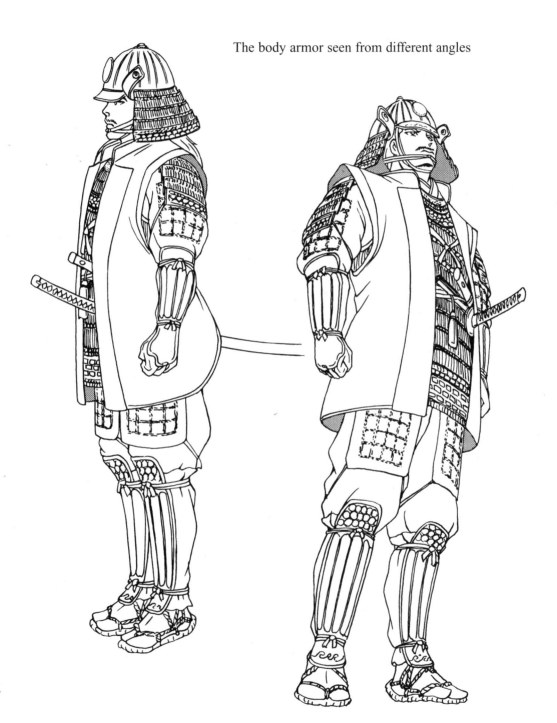

Battle-readied samurai

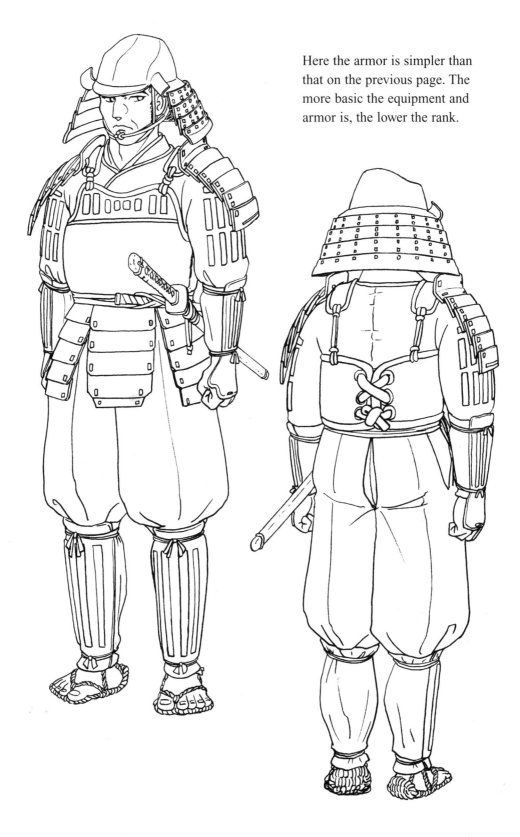

Here the armor is simpler than that on the previous page. The more basic the equipment and armor is, the lower the rank.

Battle-readied samurai

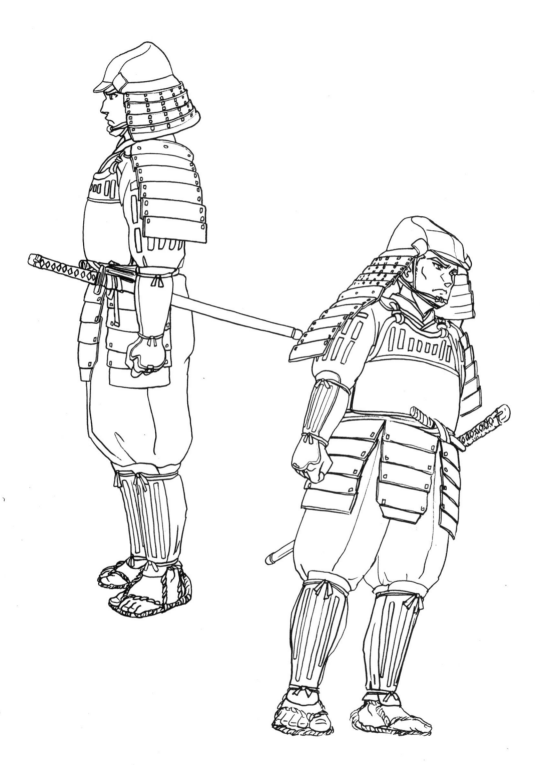

Drawing samurai

Battle-readied samurai

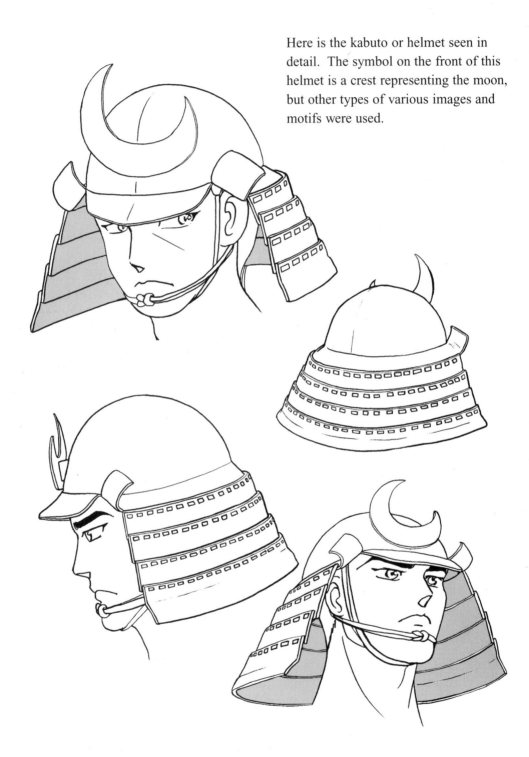

Here is the kabuto or helmet seen in detail. The symbol on the front of this helmet is a crest representing the moon, but other types of various images and motifs were used.

Battle-readied samurai

Pictured here is a different shaped kabuto seen in detail. This kabuto is fastened securely to the head by string anchored around the chin.

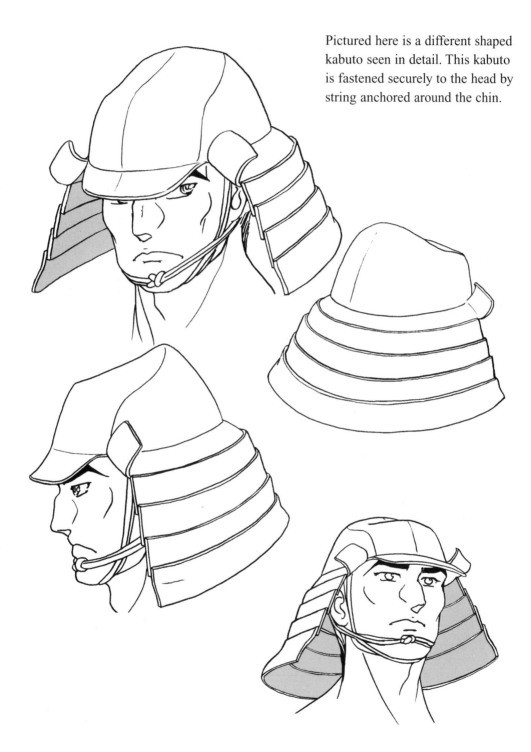

Headpiece in detail

Helmet in detail

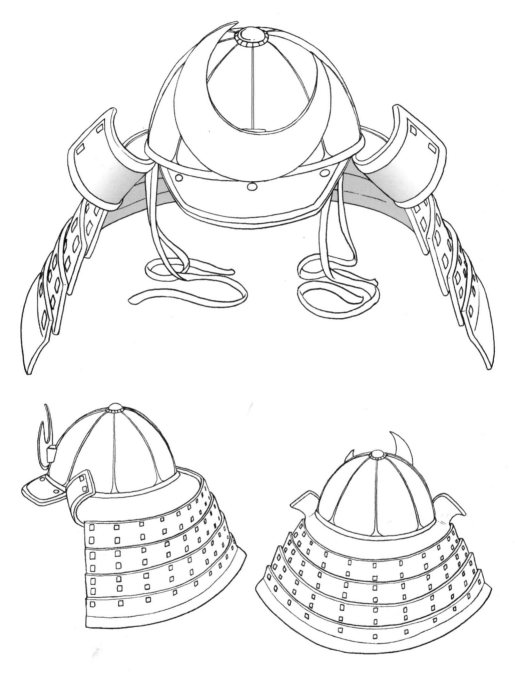

The armor worn by samurai is made of iron, even the helmet. When drawing armor, be sure to give it a heavy iron-like appearance.

Armor in detail

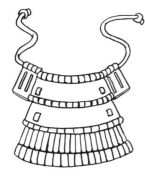

A protector hung from the neck

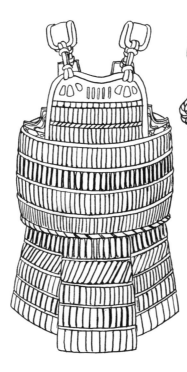

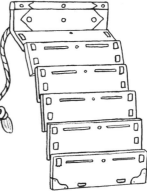

Shoulder protector

The armor that protects the torso is completely made of iron.

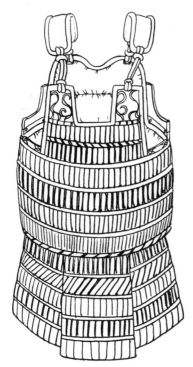

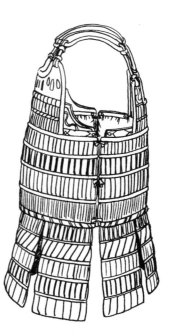

Drawing a feudal lord

Feudal Lord

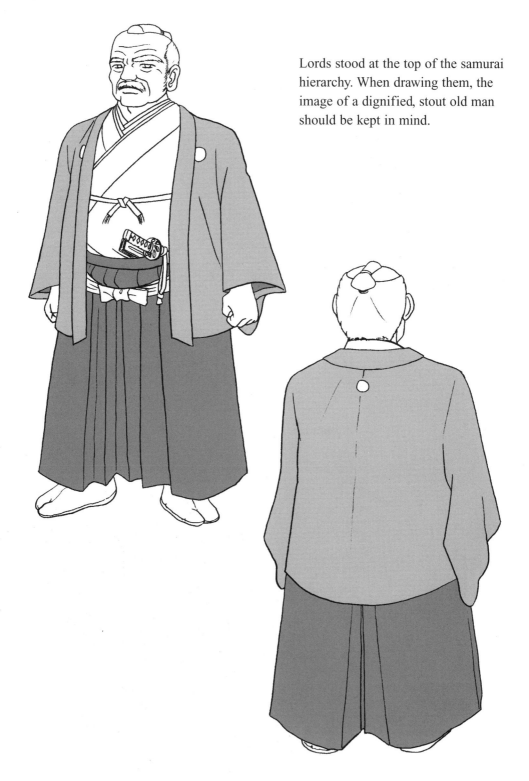

Lords stood at the top of the samurai hierarchy. When drawing them, the image of a dignified, stout old man should be kept in mind.

Feudal lord

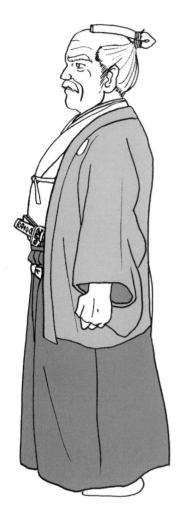

Worn above the kimono is the haori. Drawing the haori slightly longer than what might be normal, gives it a heavy look that will otherwise be missing.

A lord is often shown wearing a wakizashi (short sword). He rarely has to use it though, as he always has his own bodyguards.

Drawing a feudal lord

When a feudal lord makes an appearance, he is often shown seated like this.

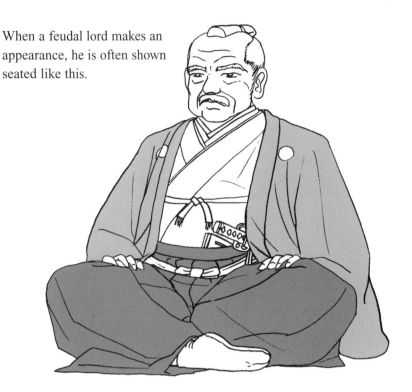

Sitting upright gives him a dignified look. When drawing a Feudal Lord in a sitting posture, be sure to give him a sense of importance.

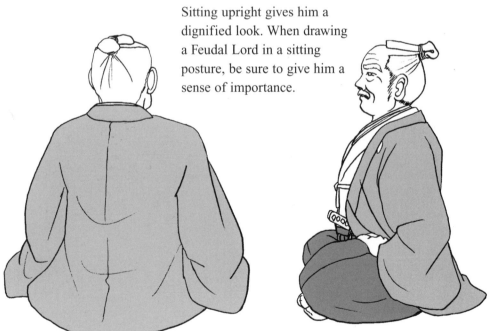

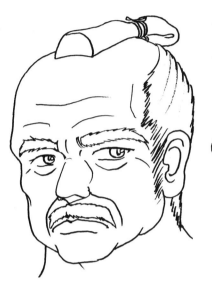

A line under the eyes and the chin gives the face a sagging look and the character added realism.

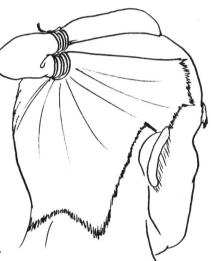

A lord's topknot is similar to other samurai. It's often drawn with plenty of gray hair.

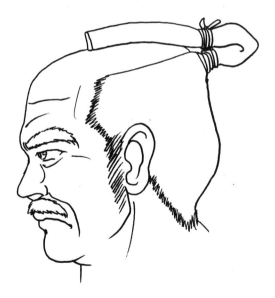

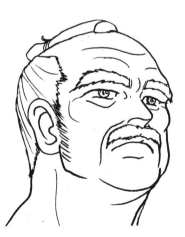

Drawing a feudal lord

The lord's gaze should be imperious looking, with his eyes looking downward as shown on the left. Having him stare out from under his brows, as in the right picture, will make him look villainous.

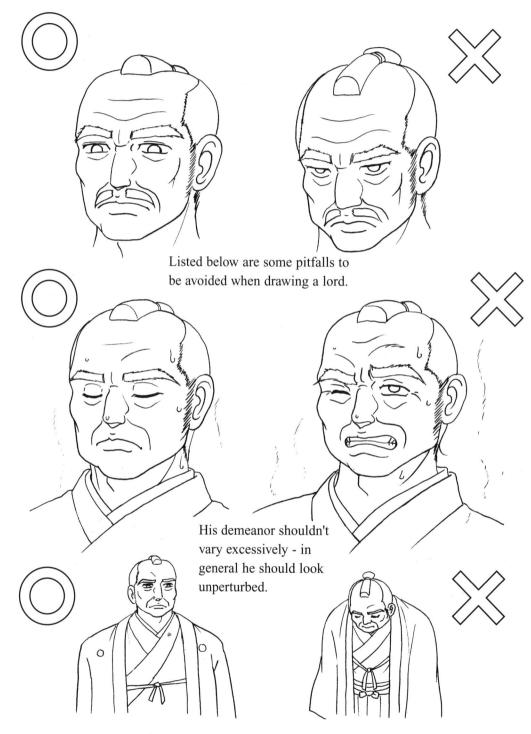

Listed below are some pitfalls to be avoided when drawing a lord.

His demeanor shouldn't vary excessively - in general he should look unperturbed.

A feudal lord should always have a military bearing, with the shoulders thrown back, and never in a slouch.

Minor details

Focus on various parts in detail (1)

Four examples of footwear

**Waraji
(Straw sandals)**
For this type of footwear, straw is woven together and held in place with a rope fastened to the ankle.

Zori (Sandals)
The soles are constructed from straw and bamboo skin, then kept in place on the foot with a thong.

**Geta
(Wooden clogs)**
This type of footwear has two slats on the underside of flat wood and a thong fastened at the top for toes to hold to.

Tabi (Socks)
Tabi are worn when wearing sandals and wooden clogs.

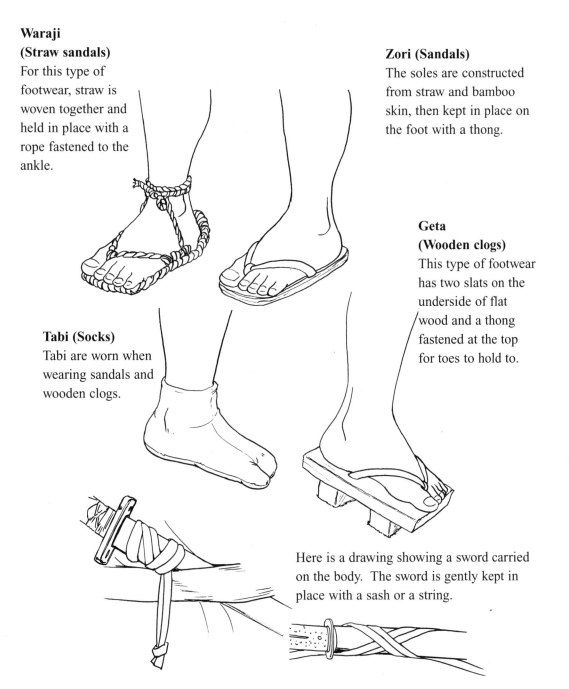

Here is a drawing showing a sword carried on the body. The sword is gently kept in place with a sash or a string.

Drawing samurai

Minor details

Focus on fine points (2)

The knot when tied at the front

The knot when tied at the back

Here you see a kimono sleeve. Inside the sleeve, there was commonly a pocket for holding loose change and small items.

Chapter 2
Drawing ninja

Ninja attire

Slender Ninja (1) Here is an example of traditional ninja clothing. The drawing pictured here is that of a slender-bodied ninja. You'll notice he's quite easy to draw and soft lines are used.

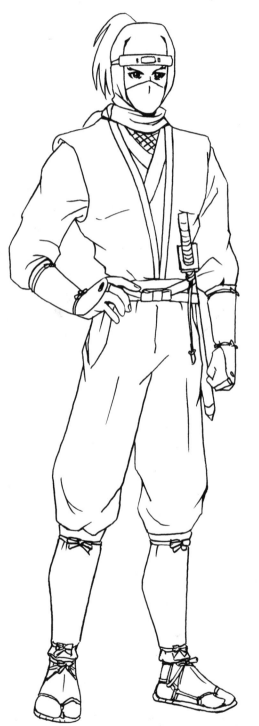

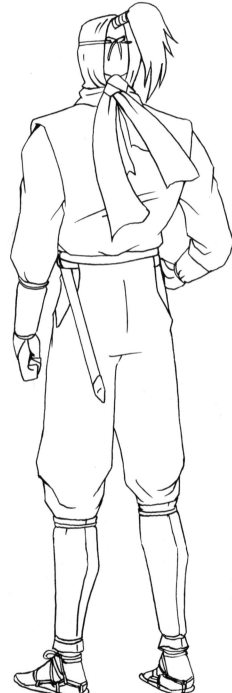

Slender Ninja (2)

The pose on the left is of a ninja about to cast a spell. His palms are together, and the index and middle finger are extended while he says a chant under his mask.

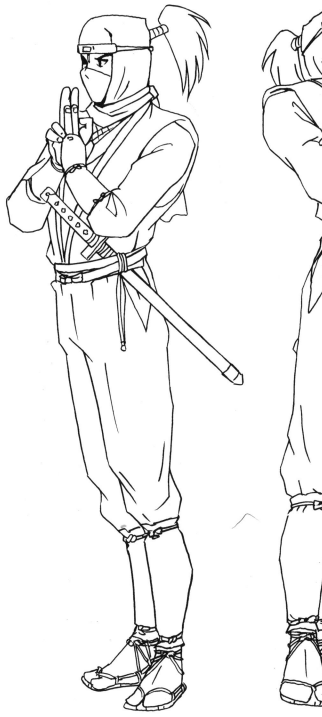

Drawing ninja

Ninja attire

A ninja with a heavier, more muscular body (1)

The ninja here is drawn with different clothes in contrast to the slender ninja on the previous page. His sword is not tucked under the belt but is roped to his back. Clothes worn by ninja vary greatly and there is no set outfit.

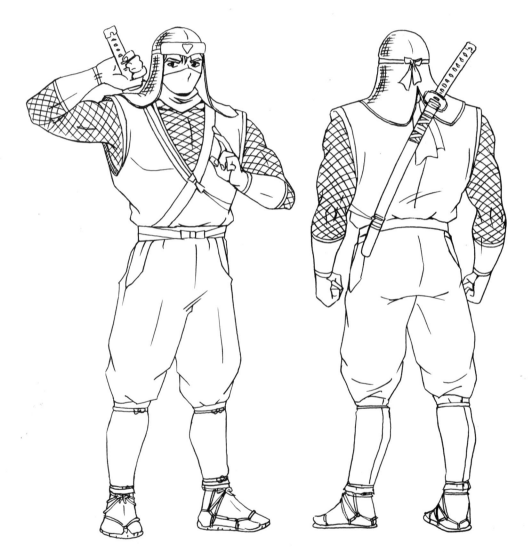

Chapter 2
Drawing ninja Ninja attire

Muscular body (2)

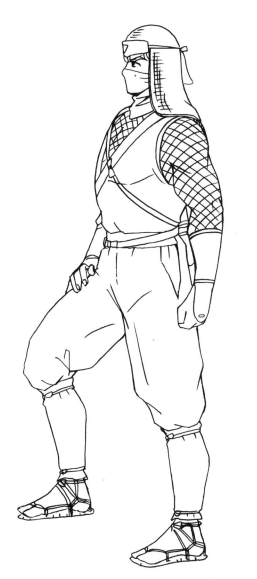

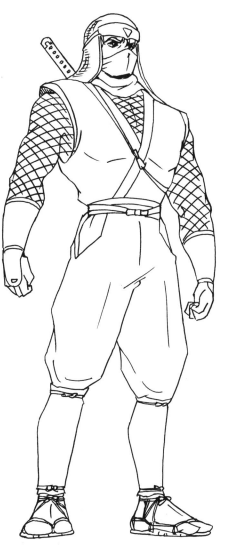

Facial close-up of a ninja

The hood-like cover worn by a ninja, called fukumen, is normally a single piece of cloth wrapped carefully around the head and face. It is used to conceal one's identity rather than provide protection.

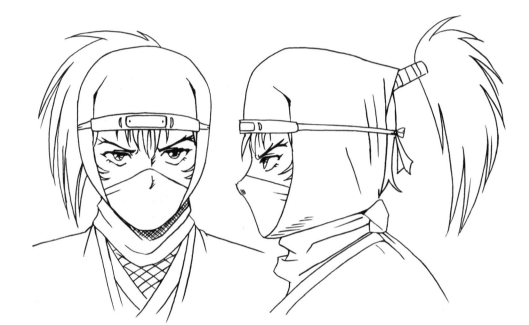

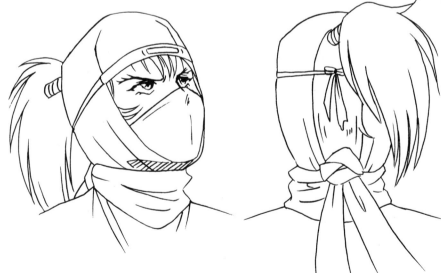

Facial close-up of a ninja

This drawing shows a thicker, more strongly woven hood. This provides some protection from enemies and is better suited for combat.

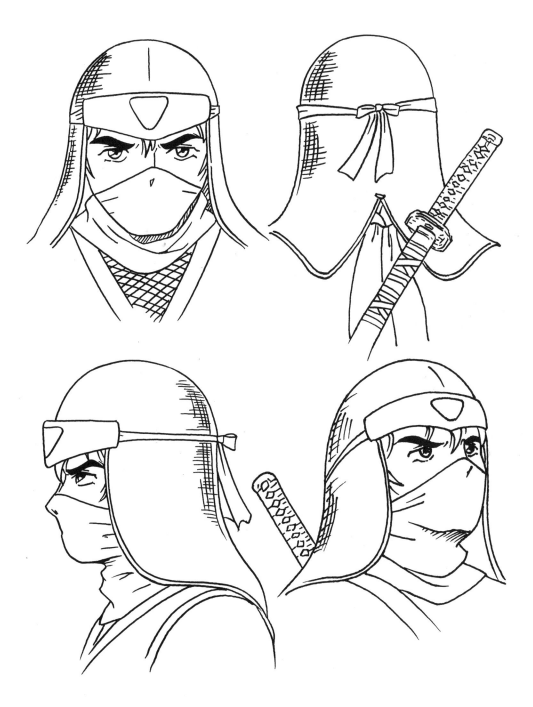

Drawing ninja

Facial close-up of a ninja

Here is the face of a ninja without his hood. Naturally the face might look like anyone, but the hair differs from samurai in that they have no topknot.

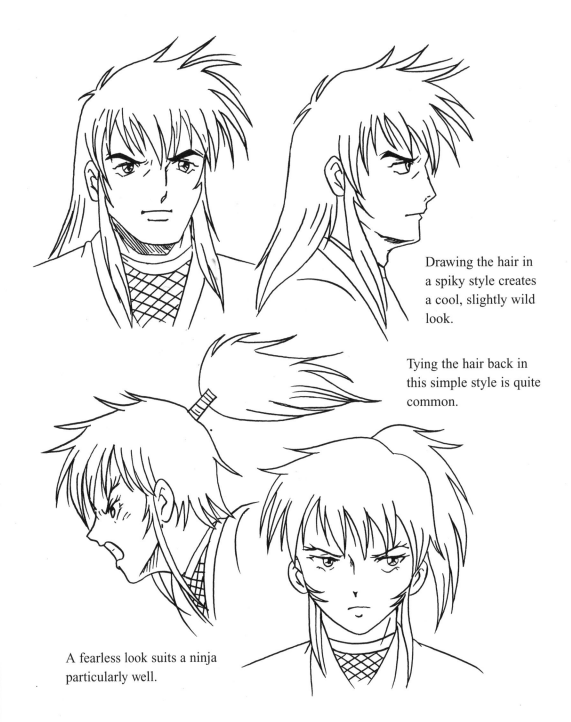

Drawing the hair in a spiky style creates a cool, slightly wild look.

Tying the hair back in this simple style is quite common.

A fearless look suits a ninja particularly well.

Ninja belongings

Focus on various details Like a samurai, a ninja generally carries only one sword, which is tucked into the belt.

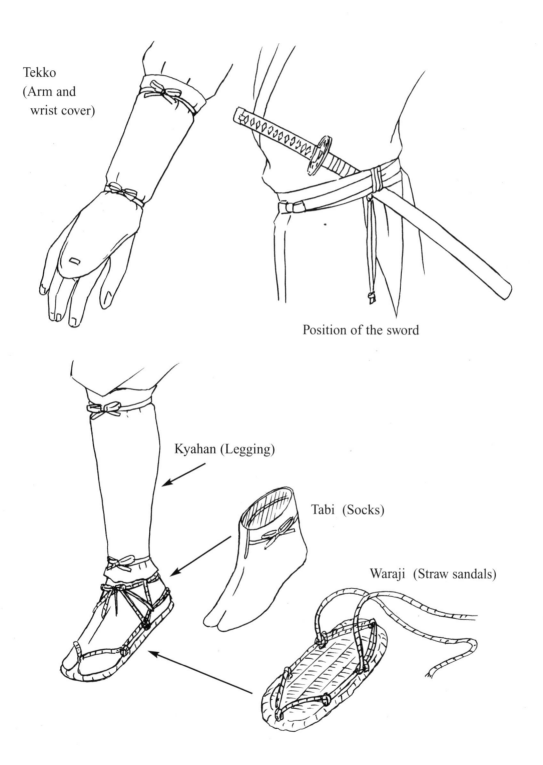

Tekko
(Arm and
 wrist cover)

Position of the sword

Kyahan (Legging)

Tabi (Socks)

Waraji (Straw sandals)

Modern ninja

A new breed of ninja

It's important to consider the total appearance, including hairstyle and clothes, when drawing ninja who exist in the current era. Here's a design that could be used in a modern story.

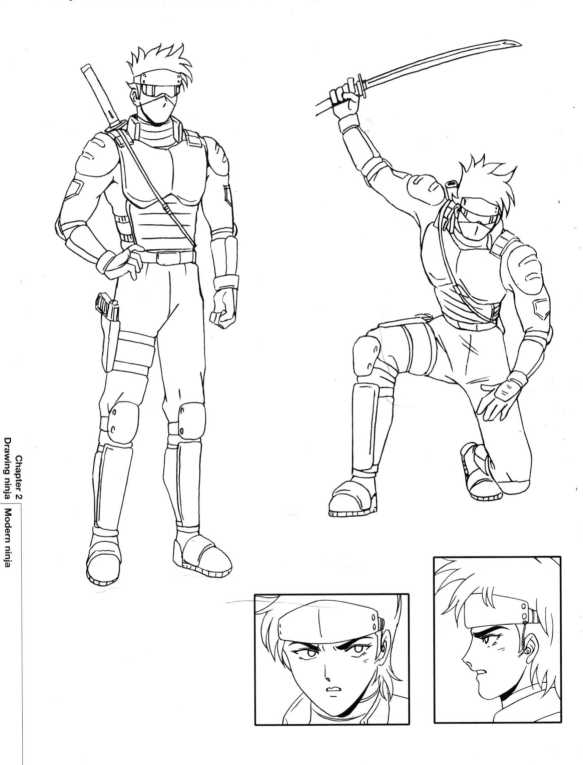

Modern ninja

Both modern day ninja and their foes, of course, would have much more powerful weapons than in the past. The Ninja shown here is wearing protection against such weapons.

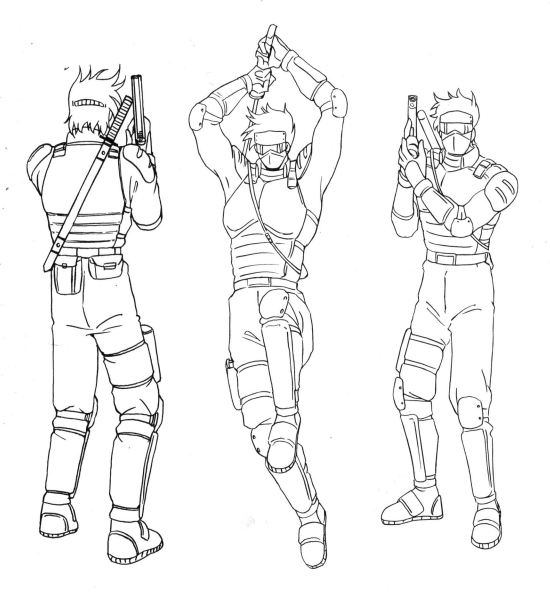

Drawing ninja

Female ninja

Common Style (1)

The female, kunoichi, ninja emerged as a type of eye-candy - perhaps more important visually than adding much else to the story. When they appear in manga they are almost always drawn to look highly appealing.

Front　　　　　　　　　Back

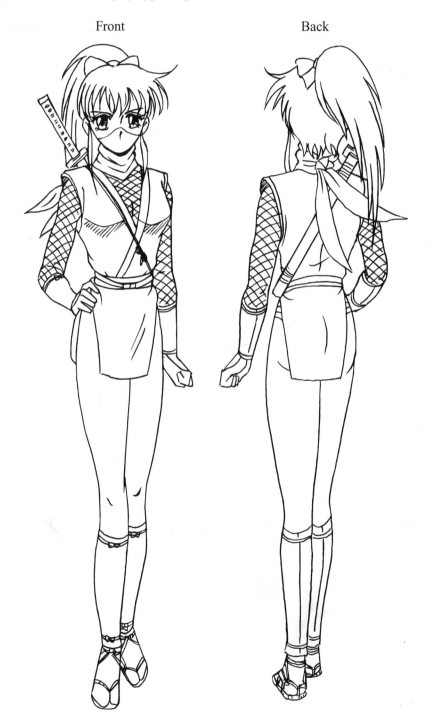

Common Style (2)

Standing eight heads tall, with her stylish hair-style, short skirt and a provocative side slit, this kunoichi exudes sexiness.

From an angle

From the side

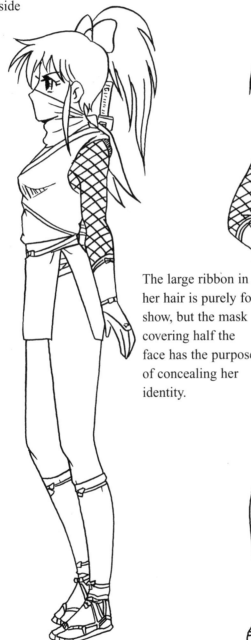

The large ribbon in her hair is purely for show, but the mask covering half the face has the purpose of concealing her identity.

Female ninja

Sexy type (1) In this drawing, the female ninja's figure and body proportions have been enhanced to make a "sexy" kunoichi. She's much more erotic-looking then the common female ninja character.

Front Back

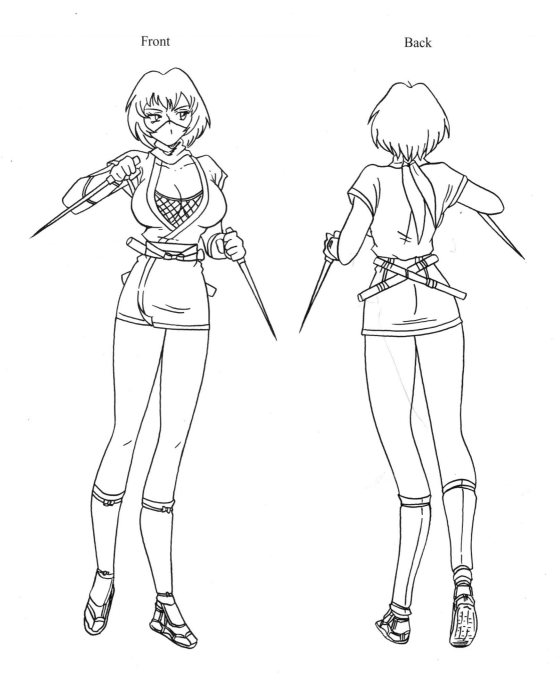

Sexy type (2)

Unlike a regular kunoichi, she only carries two small swords. Each one overlaps at the back to allow nimble movement.

From the side

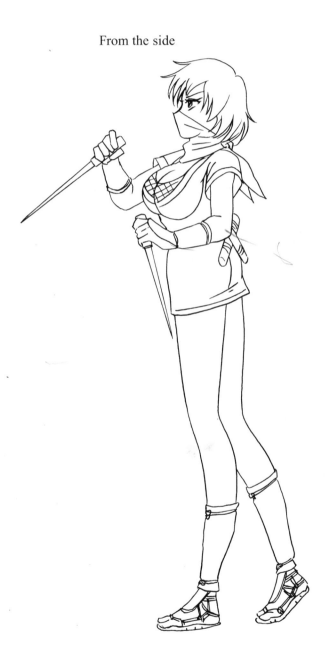

From an angle

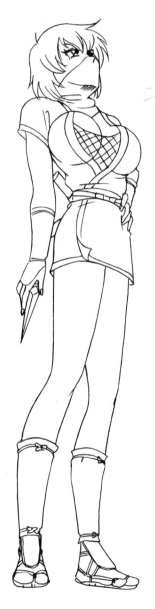

Facial close-up of a female ninja

Facial close up (1)

Facial details from another angle

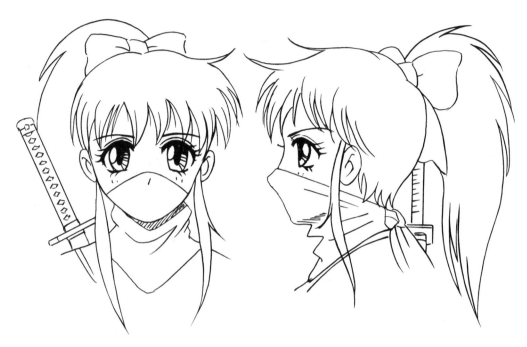

With a hood, the look is entirely different.

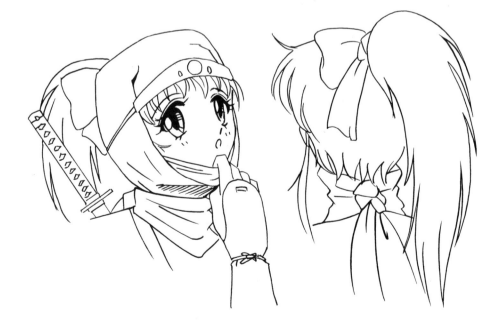

Facial close up (2)

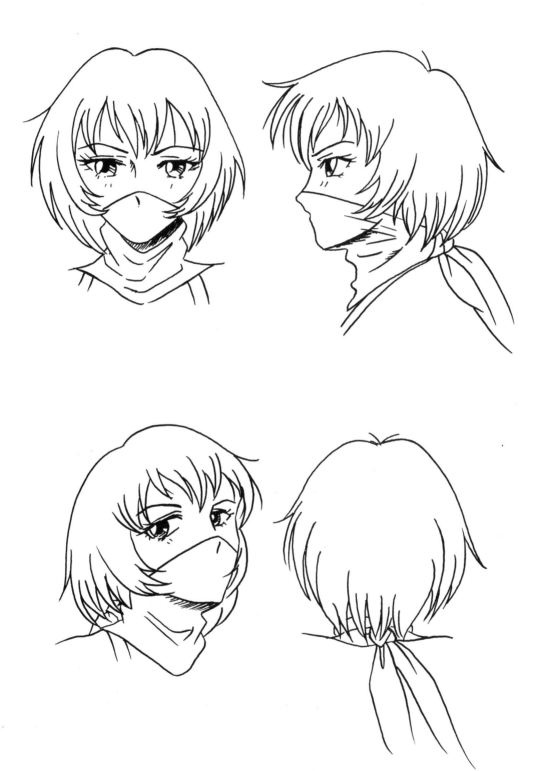

Drawing ninja
Glamorous female ninja

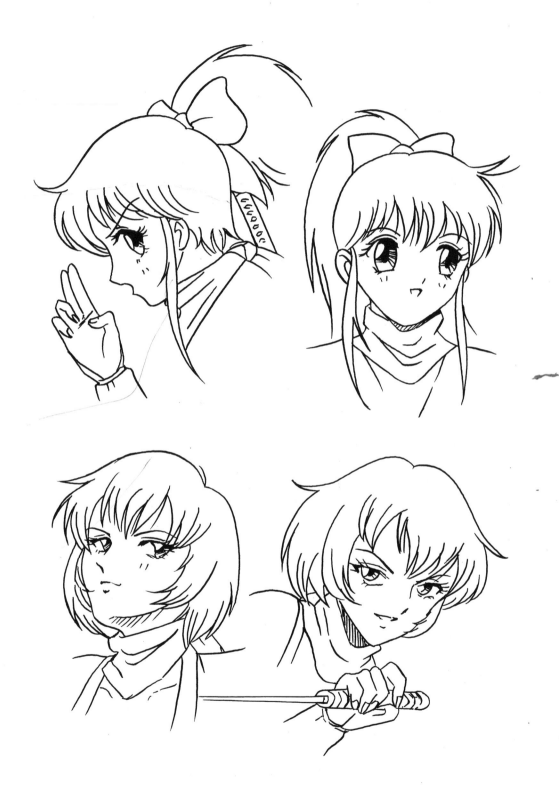

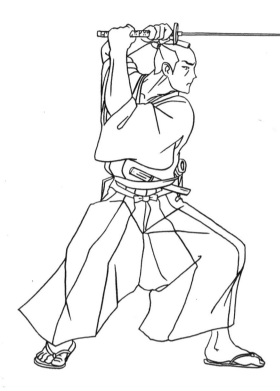

Chapter 3
Samurai in action

From first draft to inking

Walking

1. First, a very rough skeleton of the figure is drawn and an action that won't interfere with the flow of the body's movement is decided on.

2. The body is then fleshed out. At this stage, the eye line and the direction of the body is decided.

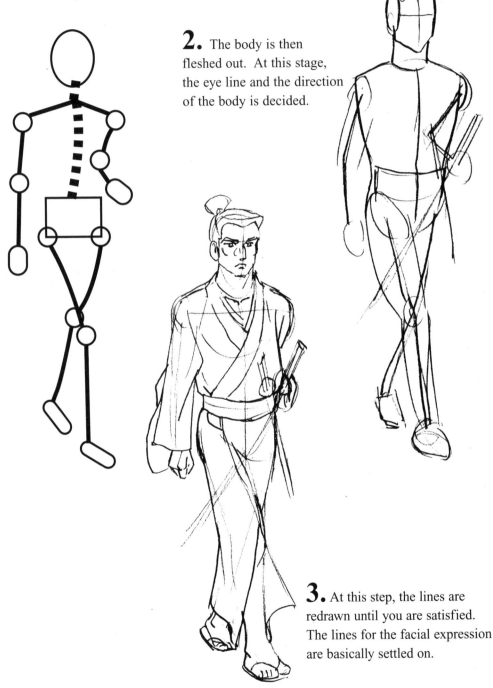

3. At this step, the lines are redrawn until you are satisfied. The lines for the facial expression are basically settled on.

Walking

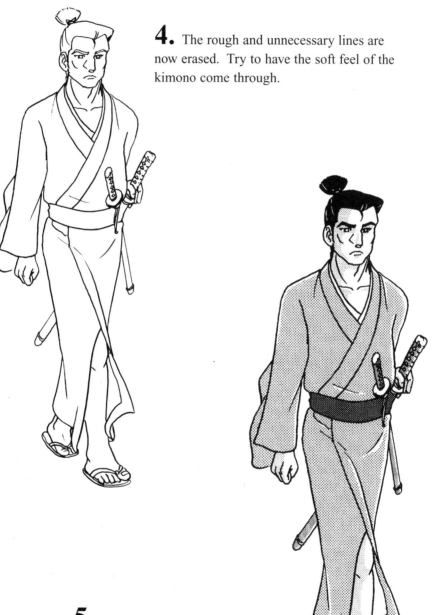

4. The rough and unnecessary lines are now erased. Try to have the soft feel of the kimono come through.

5. Add the pen lines and ink in the required areas. Complete the drawning with a screentone. Add a smidge of white ink to enhance the appearance of creases.

Samurai in action

From first draft to inking

Running Decide where the face will appear and the direction of the hips.

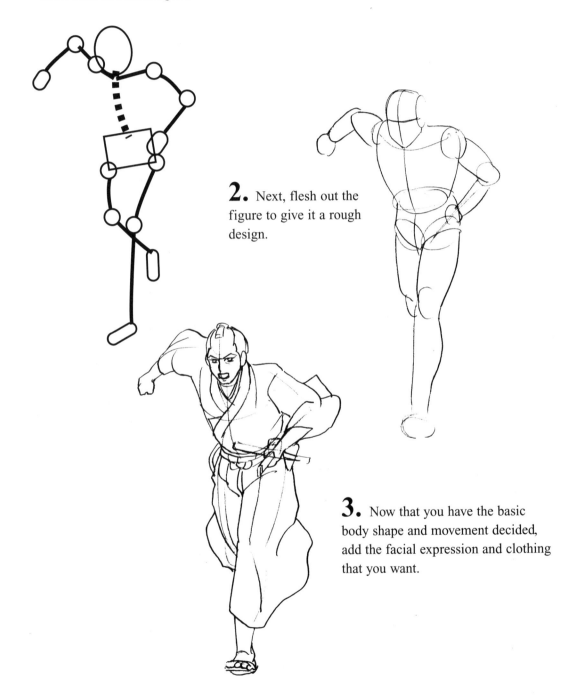

1. Draw the basic body movement as a stick figure.

2. Next, flesh out the figure to give it a rough design.

3. Now that you have the basic body shape and movement decided, add the facial expression and clothing that you want.

Running

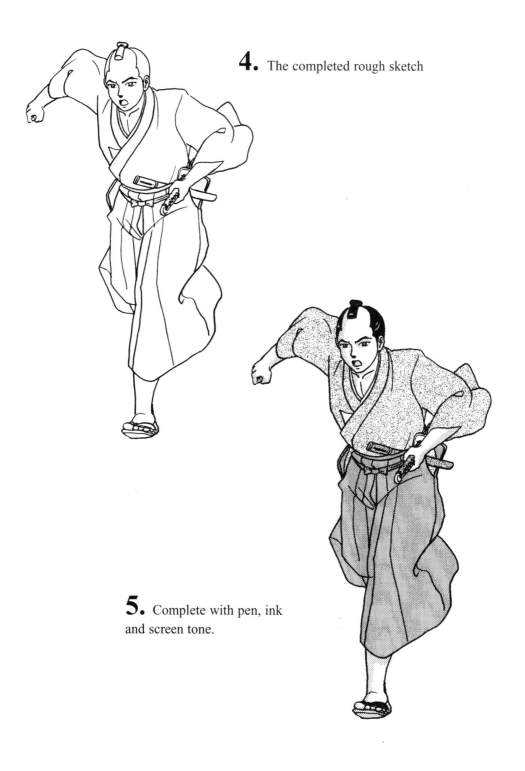

4. The completed rough sketch

5. Complete with pen, ink and screen tone.

Samurai in action

From first draft to inking

Crouching Drawing a pose with one knee resting on the ground is relatively difficult. It's best to start with a rough outline to get an overall feel for the drawing.

1. Draw the basic frame of a crouched body.

2. Flesh out the frame and decide on the eye's line of sight.

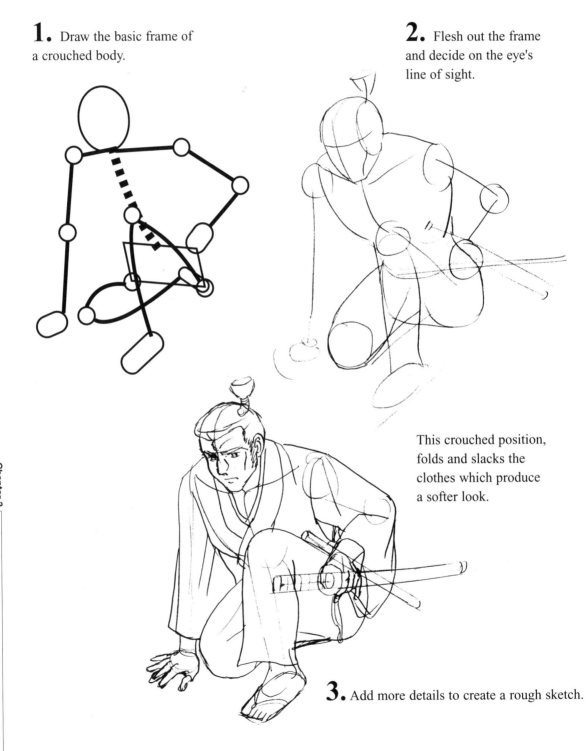

This crouched position, folds and slacks the clothes which produce a softer look.

3. Add more details to create a rough sketch.

Crouching

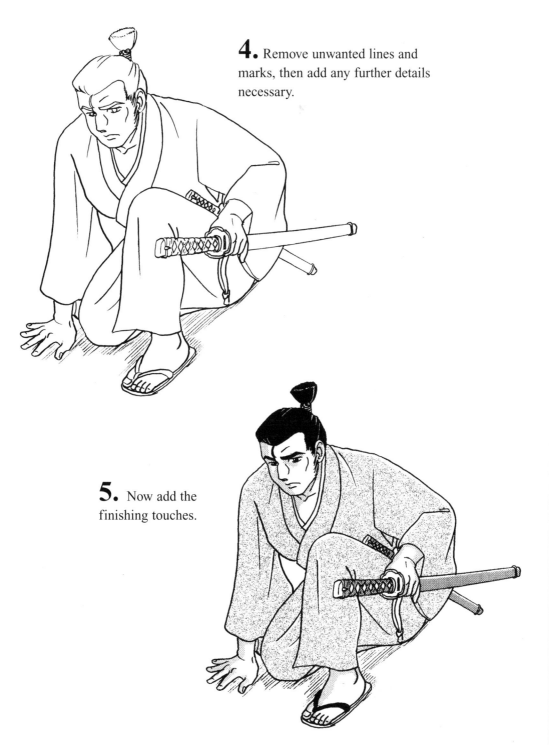

4. Remove unwanted lines and marks, then add any further details necessary.

5. Now add the finishing touches.

From first draft to inking

Sword movement The secret to drawing from front on is to use perspective in the hips and feet.

1. Basic body outline

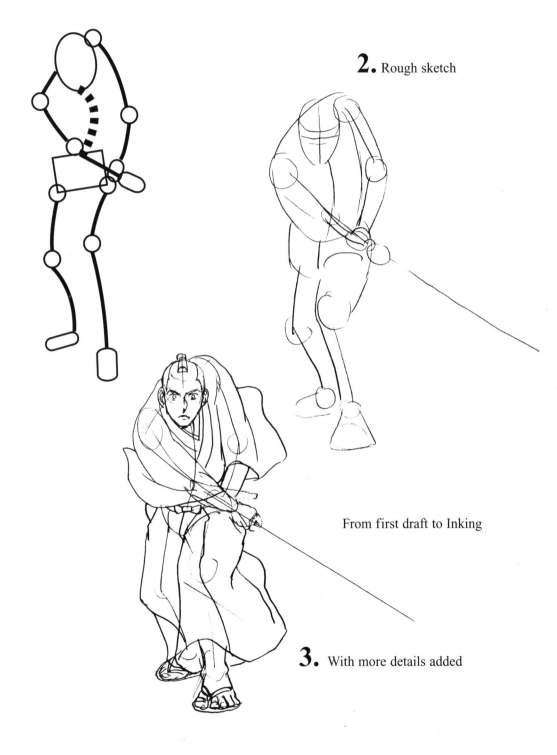

2. Rough sketch

From first draft to Inking

3. With more details added

Sword Movement Keep in mind to have the clothes fluttering in sync with the fall of the sword and that the eyes are kept fixed steely ahead.

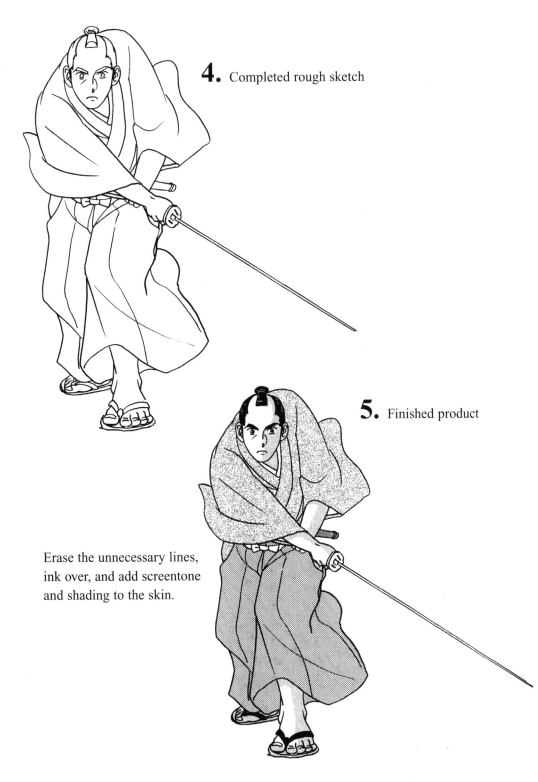

4. Completed rough sketch

5. Finished product

Erase the unnecessary lines, ink over, and add screentone and shading to the skin.

Samurai in action

From first draft to inking

Getting stabbed

Stabbed from behind, he stands motionless and shocked for a moment. Use a slight angle here.

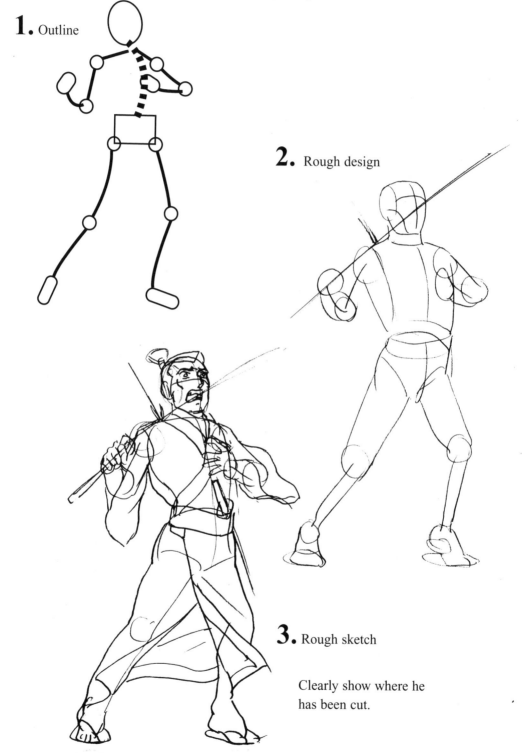

1. Outline

2. Rough design

3. Rough sketch

Clearly show where he has been cut.

Getting stabbed

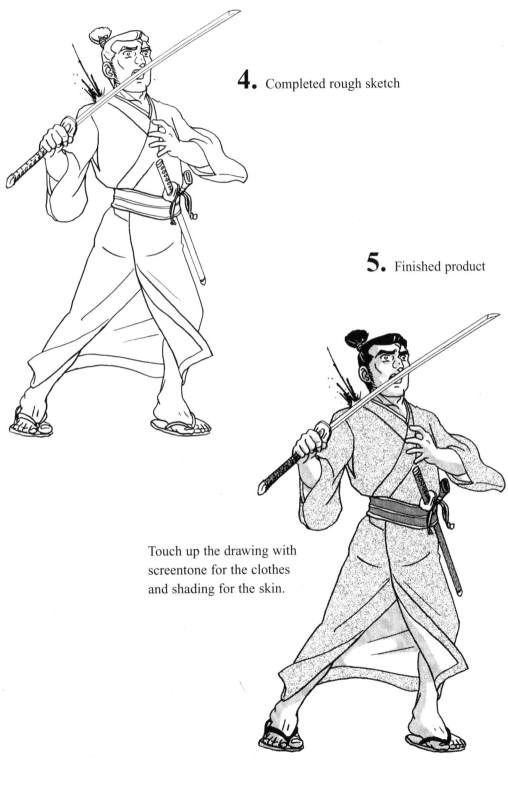

4. Completed rough sketch

5. Finished product

Touch up the drawing with
screentone for the clothes
and shading for the skin.

Samurai in action

Samurai action poses

Ready for action

This pose is often used when a samurai is preparing to attack. This stance allows the sword to be quickly sliced downward on enemies.

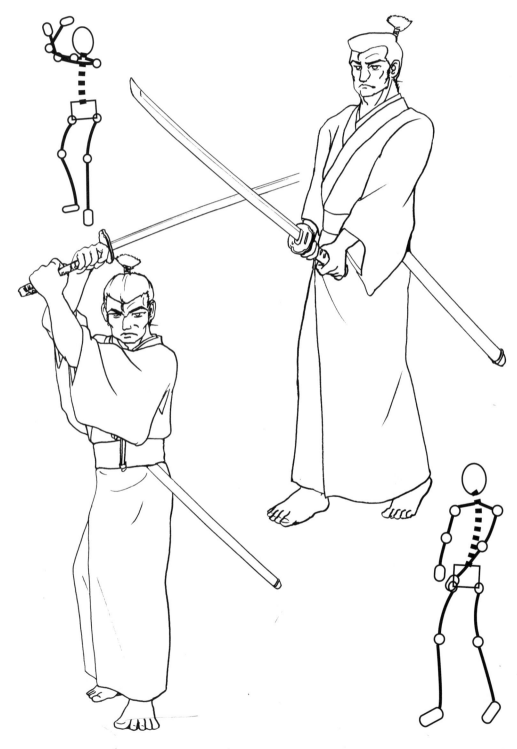

On the defensive

With the sword held
above the head

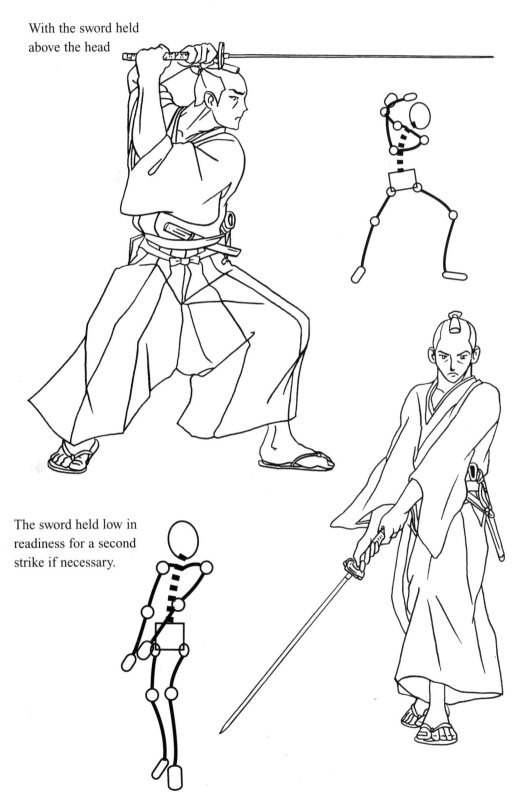

The sword held low in
readiness for a second
strike if necessary.

Samurai in action

Samurai action poses

Two-sword fighting

Normally a samurai carries the daisho, with one of the swords serving as a reserve in case the other is broken or dropped. There are also samurai that use two swords all the time. The swords can be very heavy, so tremendous upper-body strength is necessary for this type of fighting.

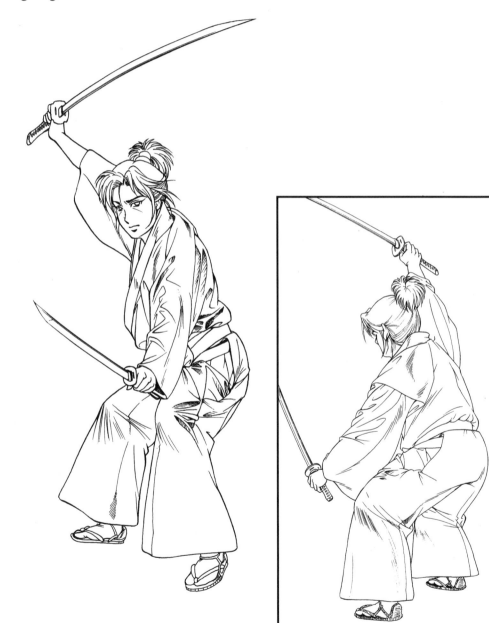

Samurai action poses

Detail of the grip on the sword

Held with both hands

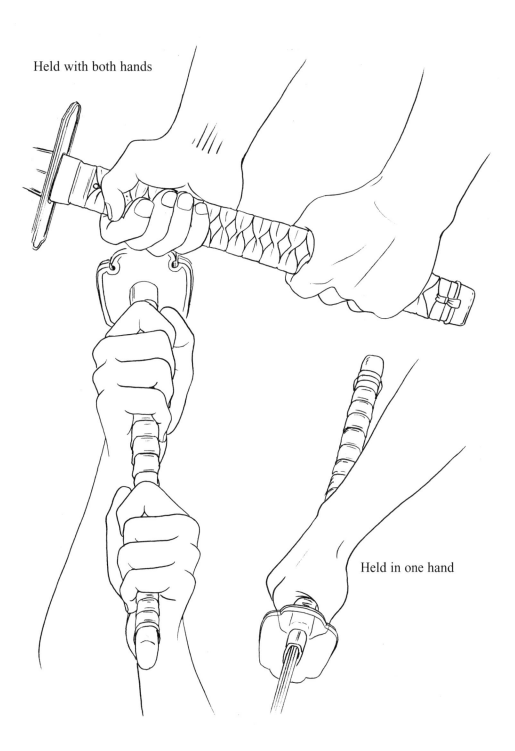

Held in one hand

Chapter 3
Samurai in action | Samurai action poses

Samurai in action

Samurai action poses

Eating

Pictured here is a samurai eating outdoors.
Notice that he appears relaxed and composed.
He has carried the rice balls in his knapsack
and uses just his hands to eat.

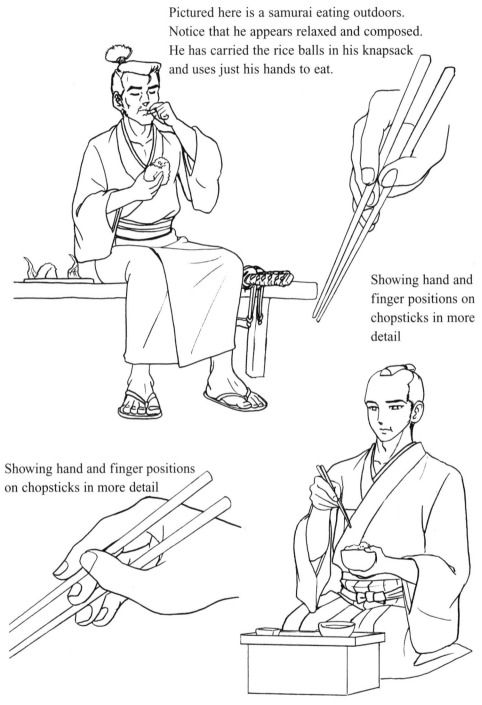

Showing hand and
finger positions on
chopsticks in more
detail

Showing hand and finger positions
on chopsticks in more detail

A samurai eating indoors with chopsticks
He is sitting in a traditional manner, and probably is in
the presence of others.

Samurai action poses

Drinking sake (rice wine)

The small cup shown here is known as yunomi. It is traditionally used to drink sake with.

With one hand on a large sake bottle (tokkuri) this samurai drinks heartily.

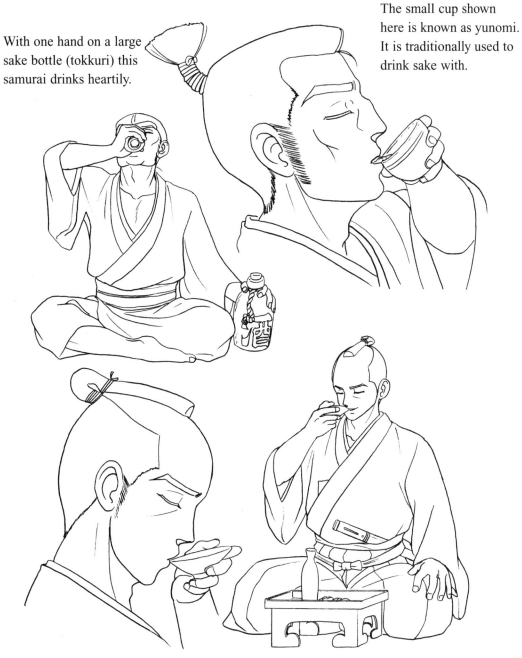

This samurai drinks sake with a shallow cup called a sakazuki. This type of cup has a more refined image.

Samurai in action

Samurai action poses

Sleeping

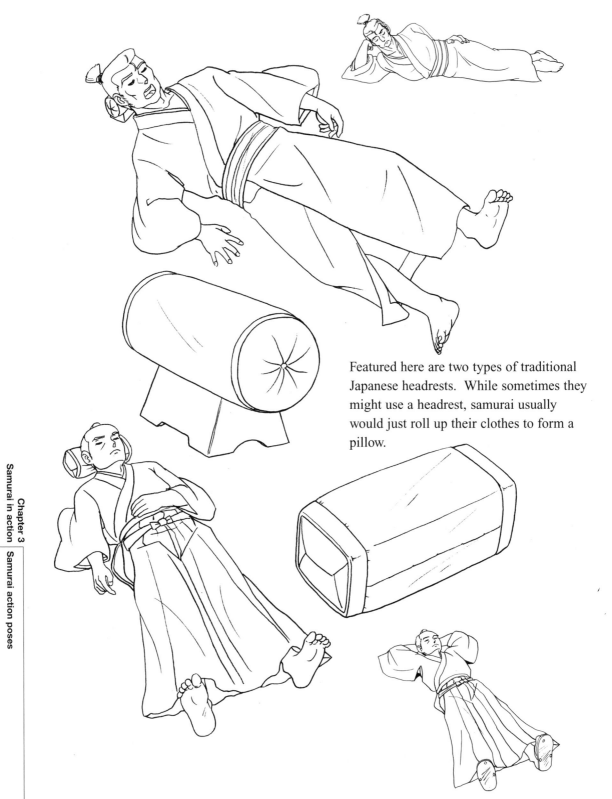

Featured here are two types of traditional Japanese headrests. While sometimes they might use a headrest, samurai usually would just roll up their clothes to form a pillow.

Samurai action poses

Riding a horse

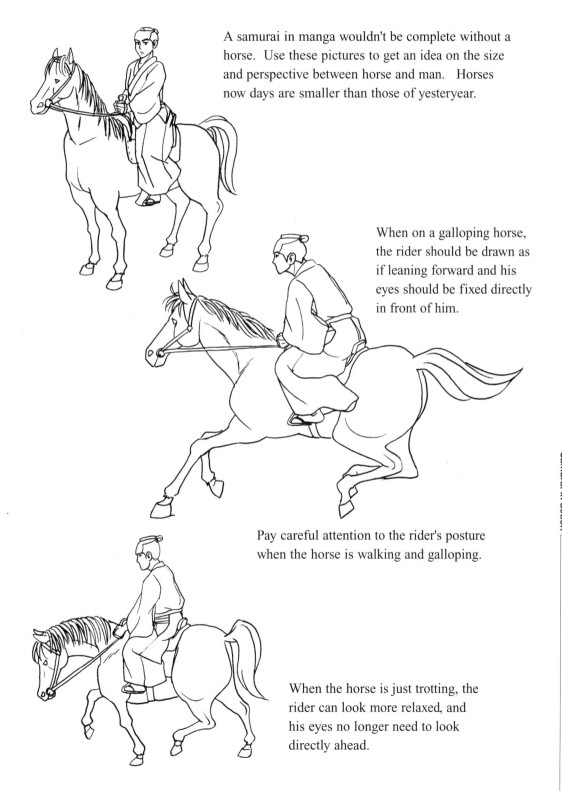

A samurai in manga wouldn't be complete without a horse. Use these pictures to get an idea on the size and perspective between horse and man. Horses now days are smaller than those of yesteryear.

When on a galloping horse, the rider should be drawn as if leaning forward and his eyes should be fixed directly in front of him.

Pay careful attention to the rider's posture when the horse is walking and galloping.

When the horse is just trotting, the rider can look more relaxed, and his eyes no longer need to look directly ahead.

Samurai in action

Samurai action poses

In the heat of a sword fight, the two samurai stare each other in the face as their swords clash against one another (1).

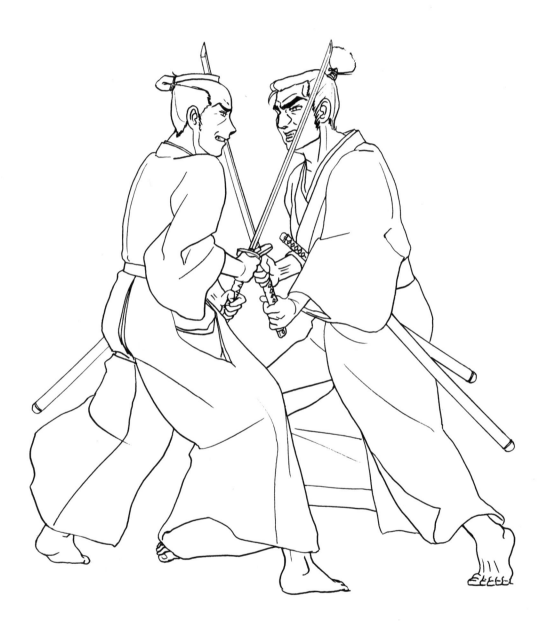

Samurai action poses

Another sword fighting scene, this time one of the samurai is on the defensive (2).

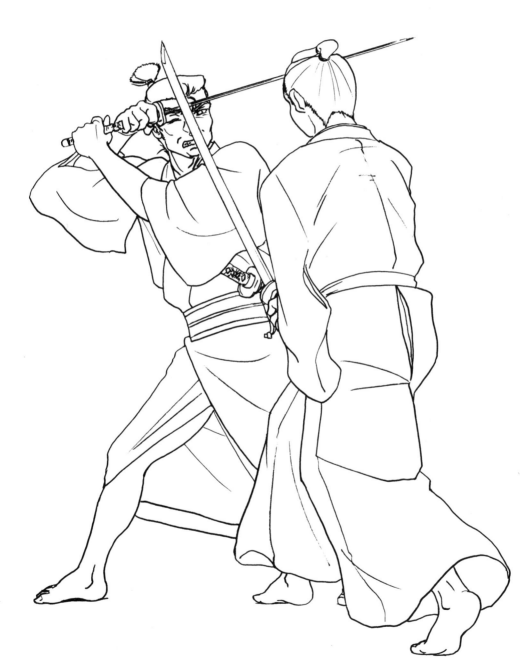

Samurai in action

Samurai action poses

Cutting and stabbing(1)

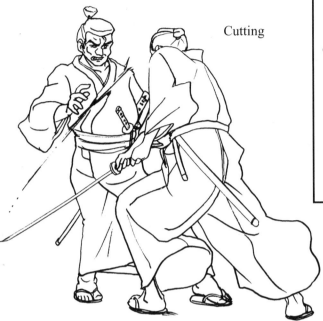

Cutting

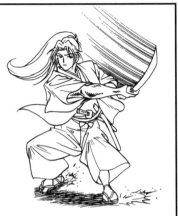

Here's a different angle to show action from the view of the opponent. Note the flowing lines give the sword speed and the lines around the feet produce a dynamic feel.

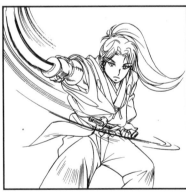

The exaggerated look of the sword and the flowing lines give this drawing a more powerful feel.

Stabbing

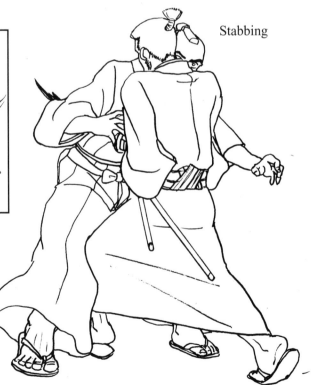

Cutting and stabbing(2)

Cutting

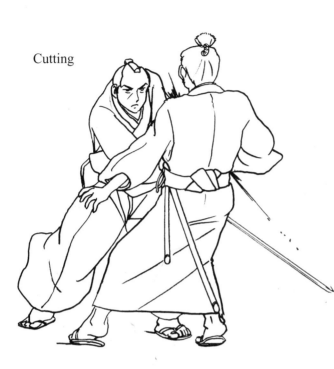

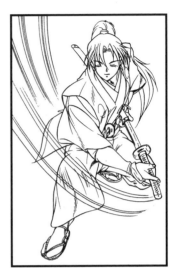

Flowing lines are used in a
big way to show the speedy
transfer of the sword to
sheath after cutting someone.

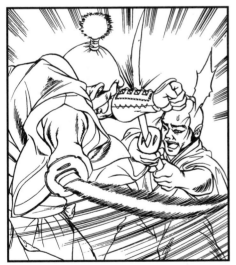

The samurai on the left is wearing a
katana-uke, made of leather and iron,
on his wrist. In face to face fights like
this, it's used to fend off sword strikes
from opponents.

Stabbing

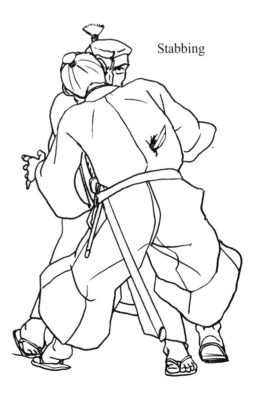

Samurai in action

Samurai facial expressions

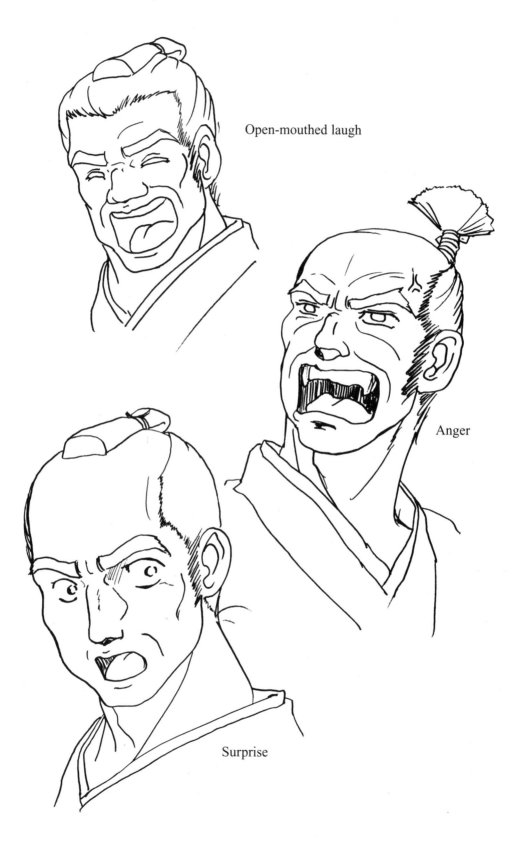

Open-mouthed laugh

Anger

Surprise

Samurai facial expressions

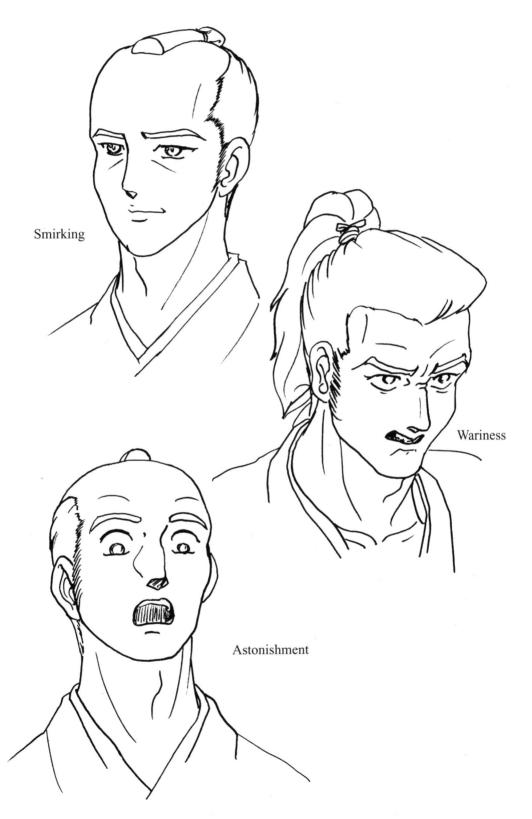

Smirking

Wariness

Astonishment

Tea break!

Tea Break!

Let's give your hand a rest! These days when Japanese hear the word "samurai" they normally associate it with historical dramas shown on television. However, there are fewer and fewer programs of this type being made now because of the huge expenses involved. Compared with a regular modern day television drama, samurai dramas have a lot of extra costs due to location factors and costumes. It's often the case that even if people want to see these type of programs, they no longer are aired. Similar to television "westerns" in America during the 50's and 60's, (such as *Bonanza* and *Laramie*), the heyday of samurai television dramas has already passed. Hopefully with the continued interest shown in the samurai history and Japanese things in general, we'll see the return of the samurai drama to the big screen and television some day soon.

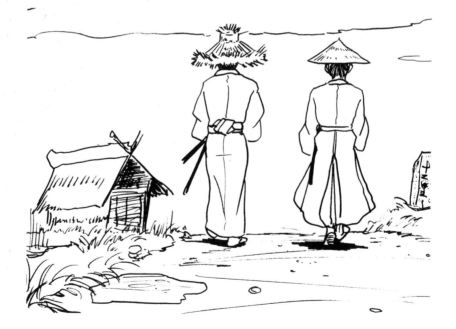

Chapter 4
Ninja in action

Ninja in Action

From first draft to inking

Running

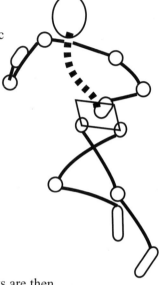

1. At first, sketch only the basic shape of the body using lines and circles as if drawing a frame.

2. The various parts are then fleshed out. At this stage, experiment with different drawing styles and various lines.

3. After deciding on the form, further details can be added - such as the clothing and the figure's facial expression.

Running

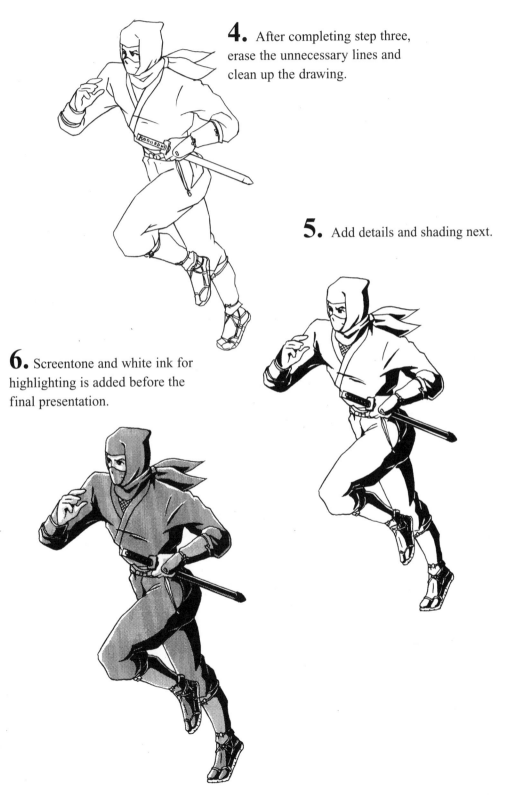

4. After completing step three, erase the unnecessary lines and clean up the drawing.

5. Add details and shading next.

6. Screentone and white ink for highlighting is added before the final presentation.

From first draft to inking

Jumping

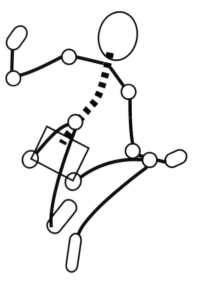

1. The general shape is sketched with lines and circles.

2. The figure is then fleshed out. The eye line and posture of the body are also decided at this stage.

3. The details are now roughly drawn in.

From first draft to inking

Jumping

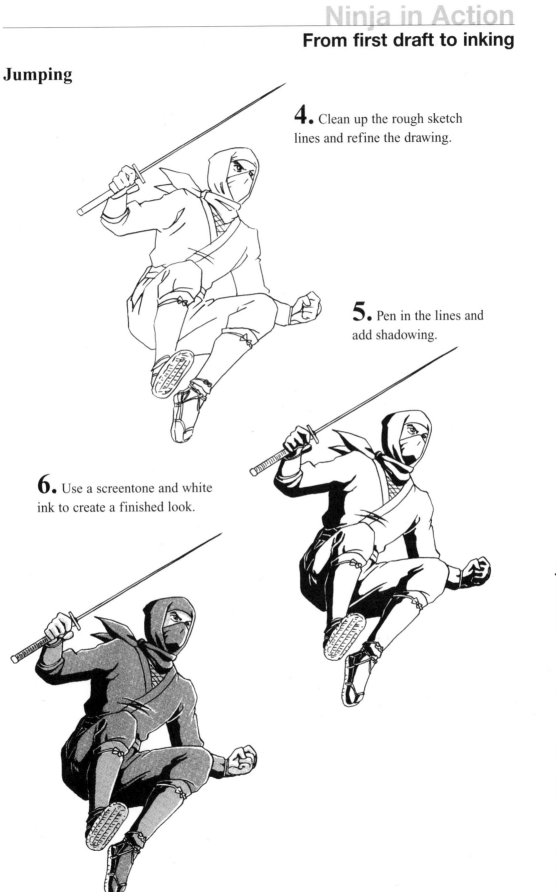

4. Clean up the rough sketch lines and refine the drawing.

5. Pen in the lines and add shadowing.

6. Use a screentone and white ink to create a finished look.

Ninja in Action

Ninja action poses

Disappearing

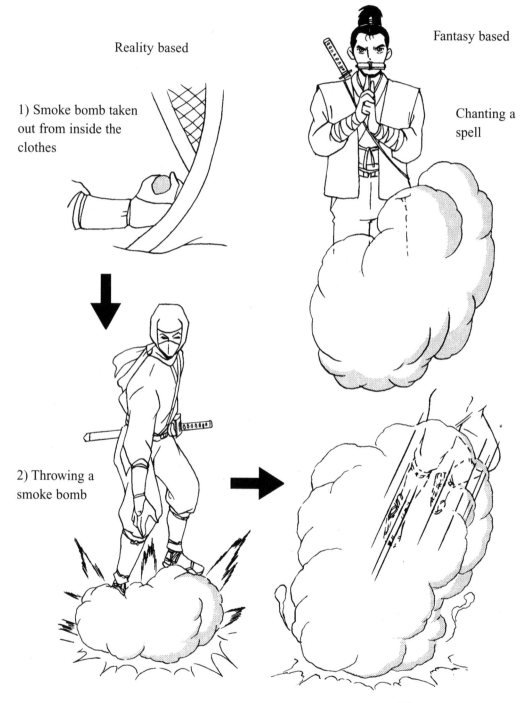

Reality based

Fantasy based

1) Smoke bomb taken out from inside the clothes

Chanting a spell

2) Throwing a smoke bomb

Disappearing in a cloud of smoke

Throwing shuriken (Stars) (1)

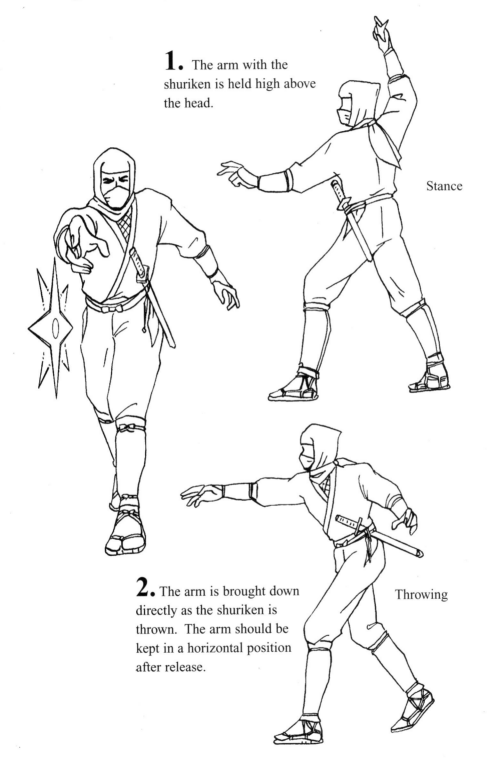

1. The arm with the shuriken is held high above the head.

Stance

2. The arm is brought down directly as the shuriken is thrown. The arm should be kept in a horizontal position after release.

Throwing

Ninja action poses

Throwing shuriken (Stars) (2)

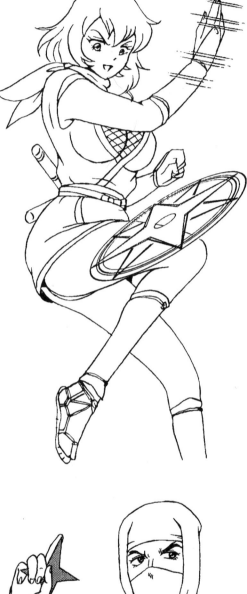

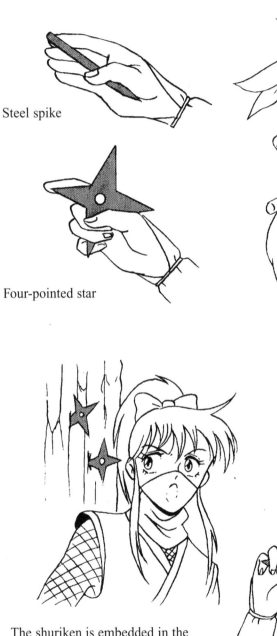

Steel spike

Four-pointed star

The shuriken is embedded in the wall, having just missed the character by inches.

Using a kusarigama (sickle and chain)

(See p101 for details of weapons)

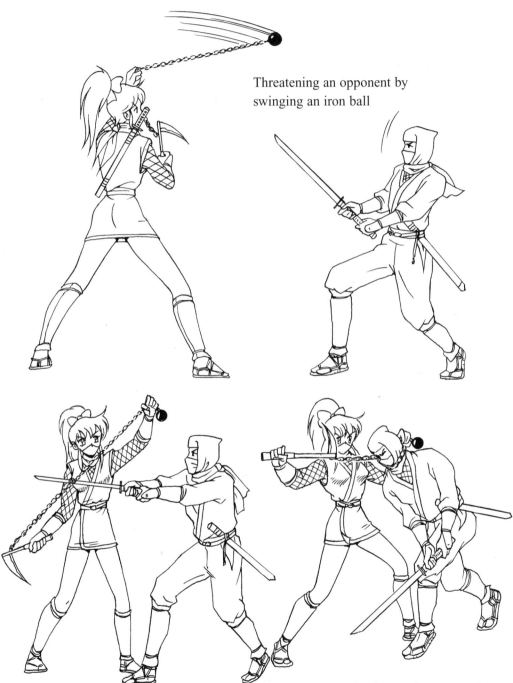

Threatening an opponent by
swinging an iron ball

Using a chain to attack

Defending against a sword
attack with a chain

Ninja in Action

Ninja action poses

Using a kamanunchaku (sickle style nunchakus)

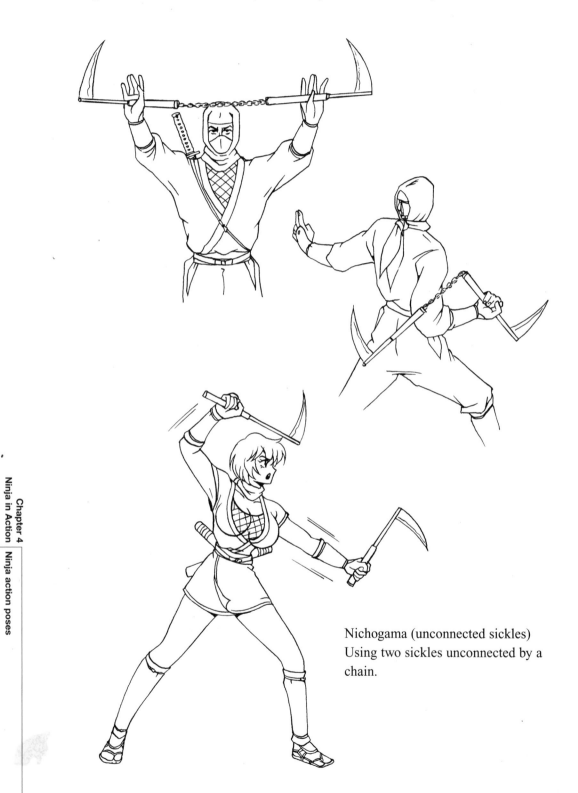

Nichogama (unconnected sickles)
Using two sickles unconnected by a chain.

Cutting

The ninto or ninja sword
has a straight blade.

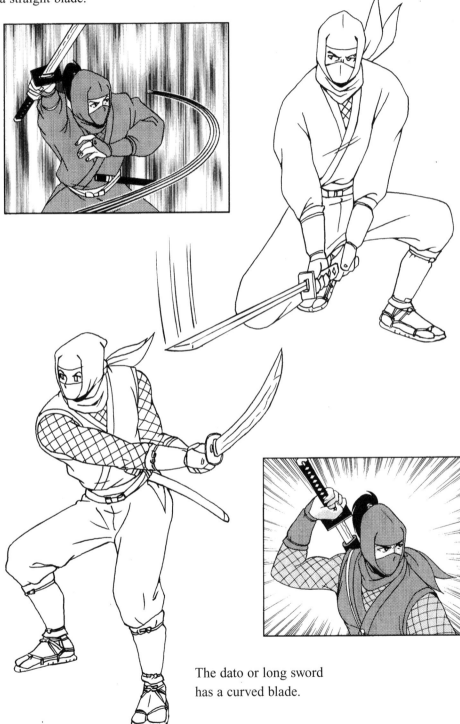

The dato or long sword
has a curved blade.

Ninja action poses

Cutting

Makibishi (Metal spikes)

When fleeing an enemy a ninja might scatter metal spikes (see p101) behind him, inflicting considerable pain if stepped on and stopping an enemy in his tracks. The same idea is used in the James Bond movie *Gold Finger,* when 007s car releases oil onto the road causing his chasers to crash.

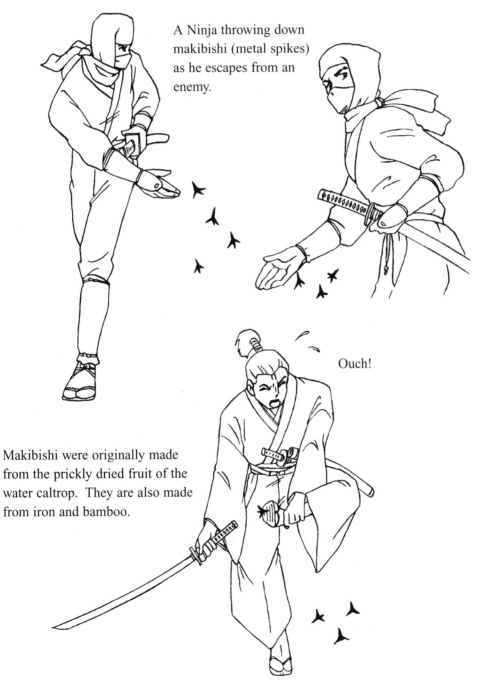

A Ninja throwing down makibishi (metal spikes) as he escapes from an enemy.

Ouch!

Makibishi were originally made from the prickly dried fruit of the water caltrop. They are also made from iron and bamboo.

Ninja action poses

On horseback

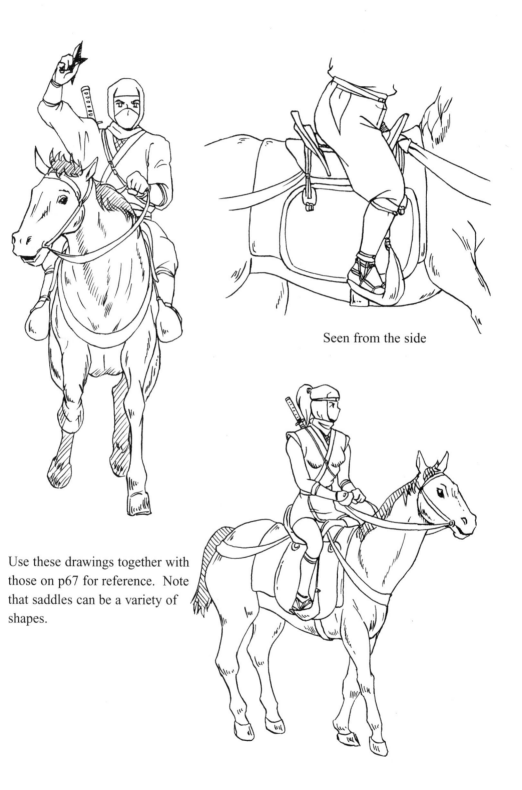

Seen from the side

Use these drawings together with those on p67 for reference. Note that saddles can be a variety of shapes.

Sword fighting (1)

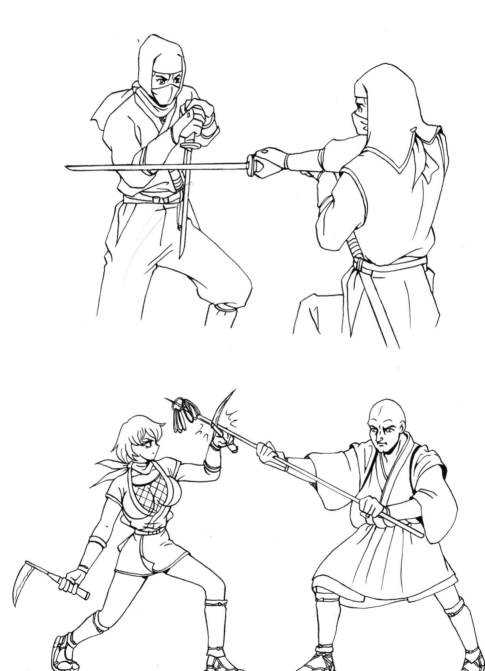

Ninja action poses

Sword fighting (2)

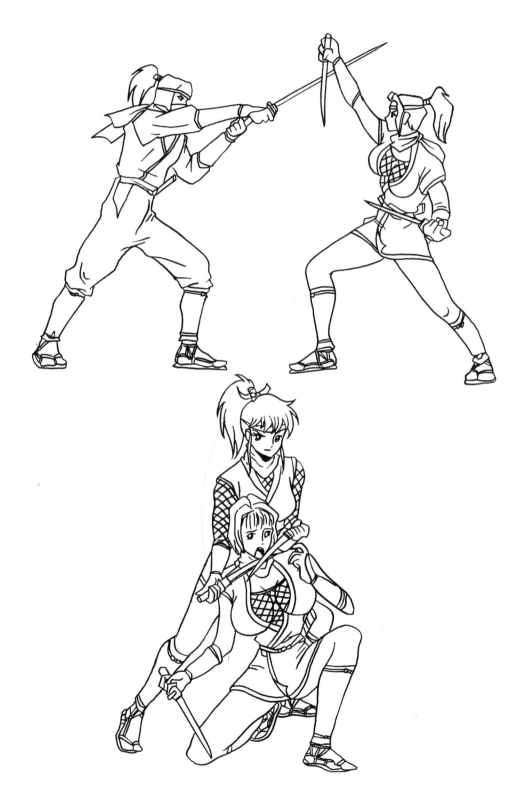

Ninja facial expressions (1)

As with samurai, there is no stereotypical ninja face. Use the faces on this page as a basis to go about creating a modern looking ninja.

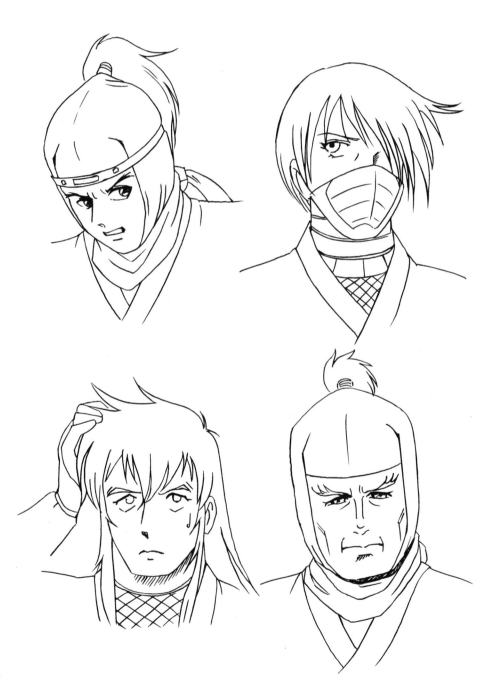

Ninja facial expressions

Ninja facial expressions (2)

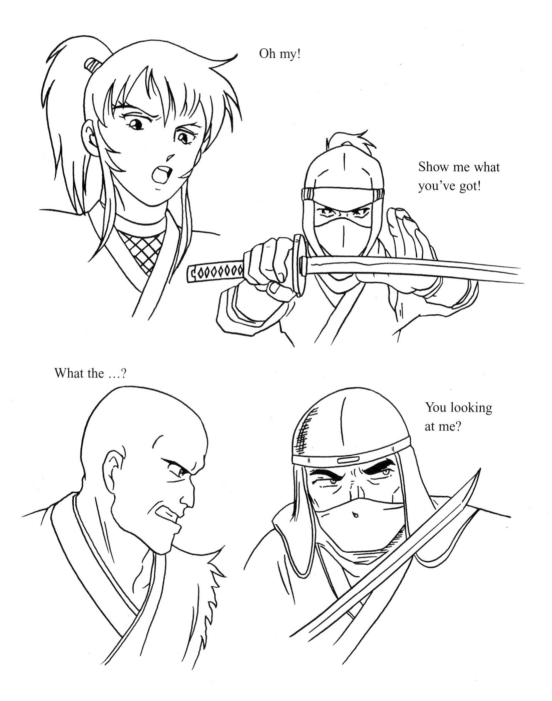

Oh my!

Show me what you've got!

What the …?

You looking at me?

Kunoichi -female Ninja (1)

The female ninja, unlike the male, was given the special name of kunoichi. They were masters of disguise and could blend into society, appearing and disappearing at will.

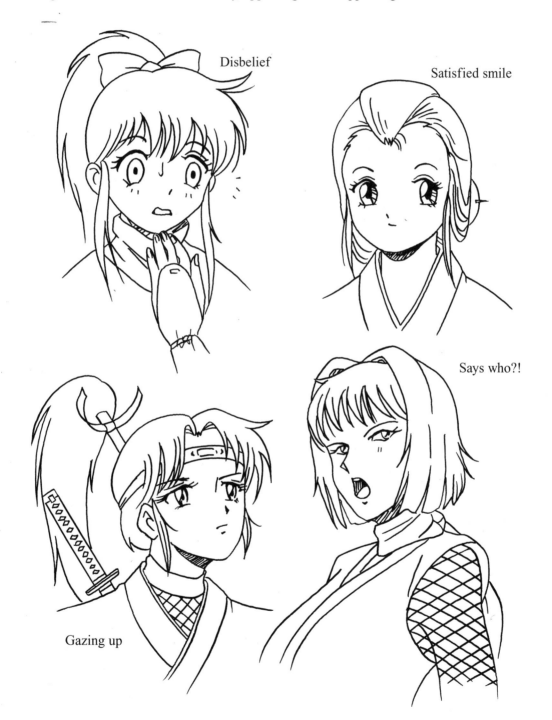

Disbelief

Satisfied smile

Says who?!

Gazing up

Ninja facial expressions

Kunoichi -female ninja (2)

Sultry delight

Mischievous smile

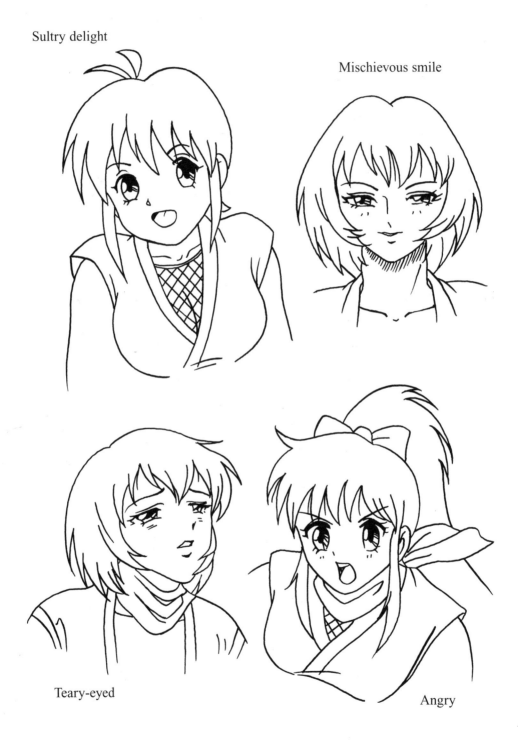

Teary-eyed

Angry

Body of a samurai

Samurai, while legendary, were after all just humans, so their body shape is just like that of modern day people. They were agile and almost never fat, so their physique is imagined to be well-developed and athletic.

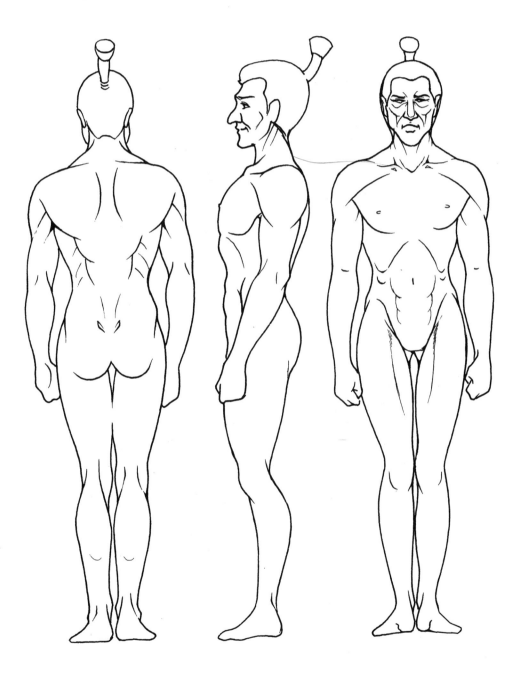

Ninja in Action

Analyzing actions

Body of a samurai

We can't draw a human body without forgetting the skeleton beneath all the flesh. However, drawing a skeleton is extremely difficult and not appropriate for establishing a shape. So without losing the shape of a skeleton, we've provided a simplified version which can be used to flesh out a body.

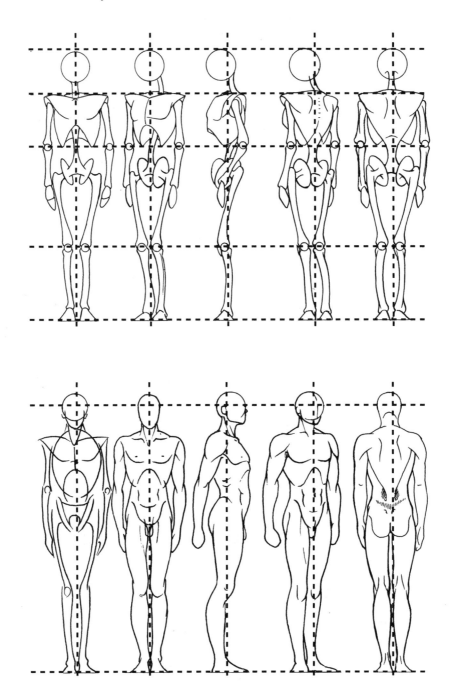

Body of a samurai

Drawing a skeleton - joints and body shape

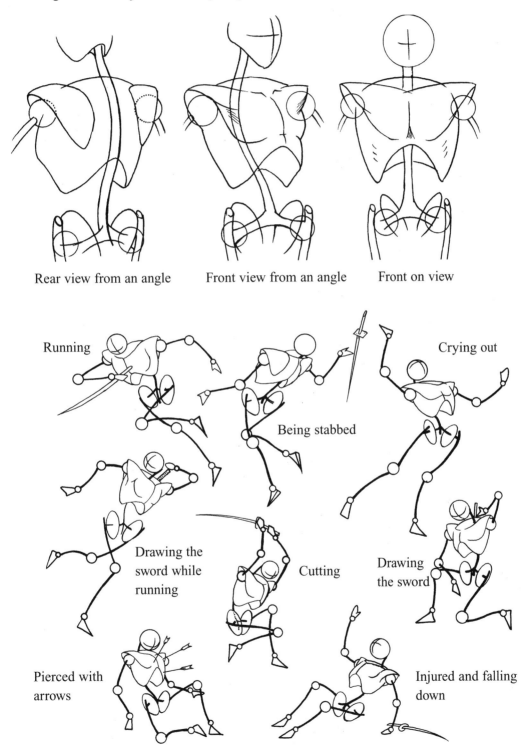

Rear view from an angle　　Front view from an angle　　Front on view

Running

Crying out

Being stabbed

Drawing the
sword while
running

Cutting

Drawing
the sword

Pierced with
arrows

Injured and falling
down

Tea Break!

Let's take another breather here. Readers might be thinking to themselves that they'd like to try their hand at being a ninja or samurai for a day. Impossible, you may think in this time and age. However, in the town of Nikko, about two hours north of Tokyo, and in the Uzumasa area of Kyoto, there are theme parks dedicated to this bygone age. At both of these famous locations, you'll not only find ninja and samurai, but also whole buildings from that era of Japanese history. If you're lucky, you might even see them filming a movie on the day of your visit.

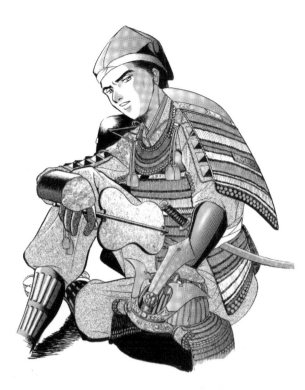

武

Chapter 5
Weapons, personal effects and background

Weapons and personal effects

Japanese sword

Let's take a detailed look at the Japanese sword.

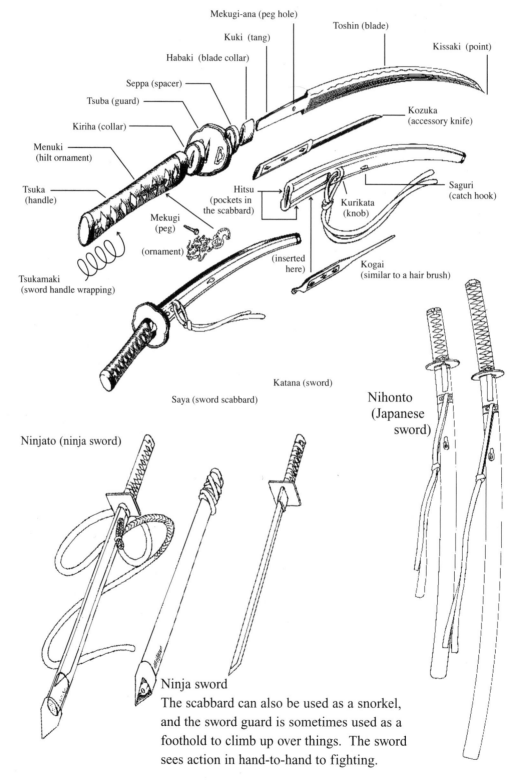

Mekugi-ana (peg hole)

Kuki (tang)

Toshin (blade)

Kissaki (point)

Habaki (blade collar)

Seppa (spacer)

Tsuba (guard)

Kiriha (collar)

Kozuka
(accessory knife)

Menuki
(hilt ornament)

Tsuka
(handle)

Hitsu
(pockets in
the scabbard)

Kurikata
(knob)

Saguri
(catch hook)

Mekugi
(peg)

(ornament)

(inserted
here)

Kogai
(similar to a hair brush)

Tsukamaki
(sword handle wrapping)

Katana (sword)

Saya (sword scabbard)

Nihonto
(Japanese
sword)

Ninjato (ninja sword)

Ninja sword
The scabbard can also be used as a snorkel,
and the sword guard is sometimes used as a
foothold to climb up over things. The sword
sees action in hand-to-hand to fighting.

Metal spikes, spear and sickle and chain

From wood through to iron, makibishi (metal spikes) come in an array of materials.

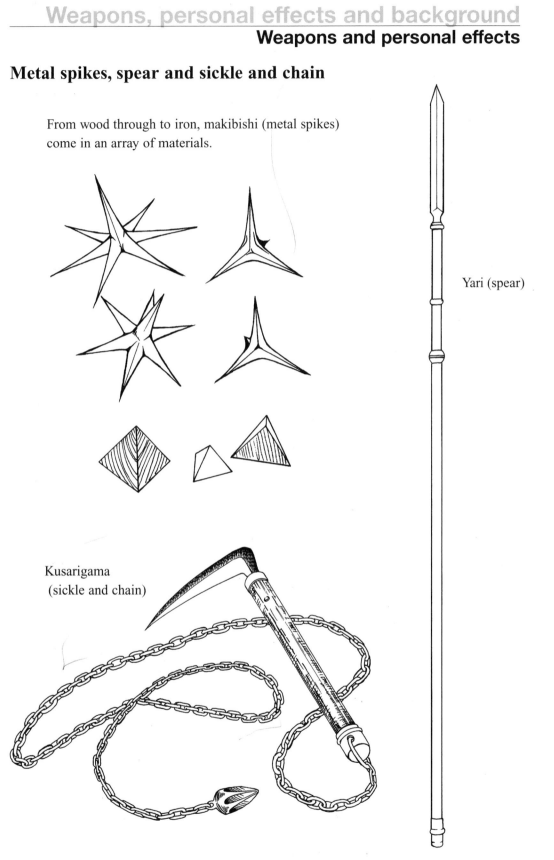

Yari (spear)

Kusarigama
(sickle and chain)

Weapons and personal effects

Shuriken-throwing stars

Method of holding
and throwing

Windmill shaped stars

Various types of dagger-like shuriken

Pointed upwards

Method of holding and throwing spikes

Thrown straight

Thrown with spin

Weapons and personal effects

Water walking device and kusari bundo, weighted chain

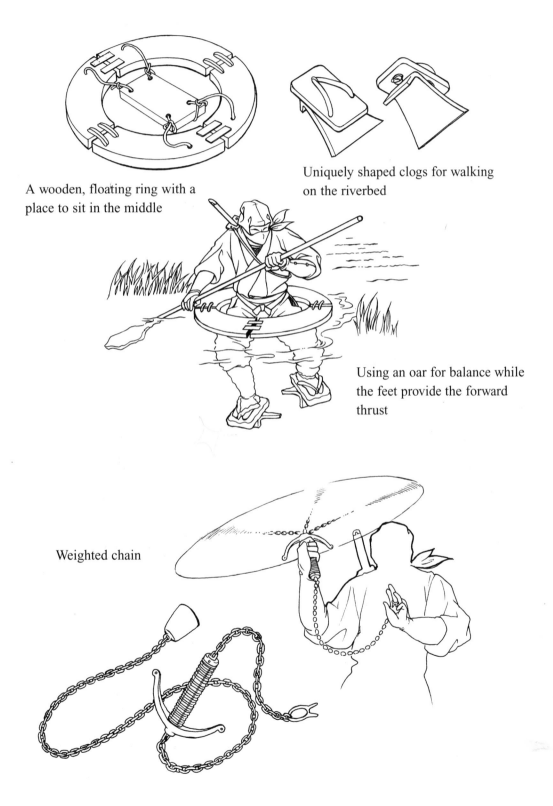

A wooden, floating ring with a place to sit in the middle

Uniquely shaped clogs for walking on the riverbed

Using an oar for balance while the feet provide the forward thrust

Weighted chain

Weapons and personal effects

Drawing the horse (1)

Drawing any sort of animal, not just a horse, is no easy task. Since the horse is an integral part of the characters within this book, here are some pointers to remember when drawing the animal. The horse's body should be viewed as separate components of a whole.

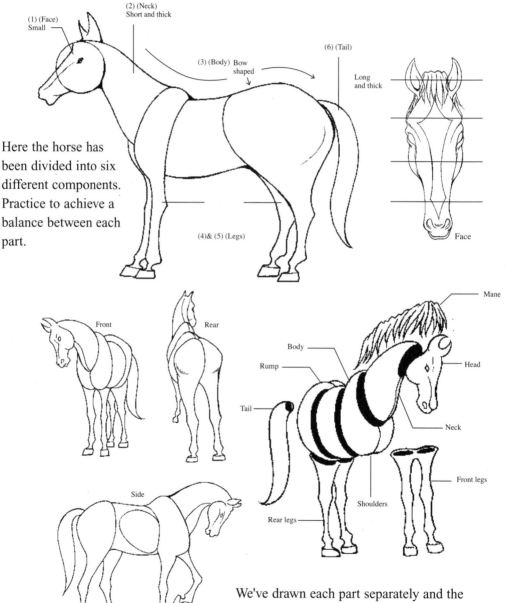

(2) (Neck)
Short and thick

(1) (Face)
Small

(6) (Tail)

(3) (Body) Bow
shaped

Long
and thick

Here the horse has been divided into six different components. Practice to achieve a balance between each part.

(4)& (5) (Legs)

Face

Front

Rear

Mane

Body

Rump

Head

Tail

Neck

Side

Front legs

Shoulders

Rear legs

We've drawn each part separately and the horse from three angles. Use this as a base to refine your drawing skills.

Weapons and personal effects

Drawing the Horse (2)

Pictured here is a horse running. When drawing a horse in an
action movement, be careful to capture the correct bend of its legs.

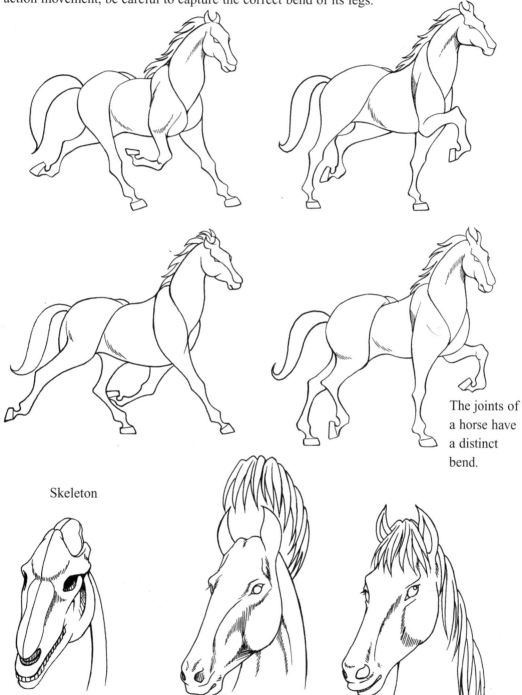

The joints of
a horse have
a distinct
bend.

Skeleton

Imagine the mane as a separate component, and draw it
almost as if placing a wig on the horse's back.

Weapons and personal effects

Harness

There are an enormous amount of items that might be found attached to a horse. Although they appear as decorations, the pieces attached to the harness below are for fighting.

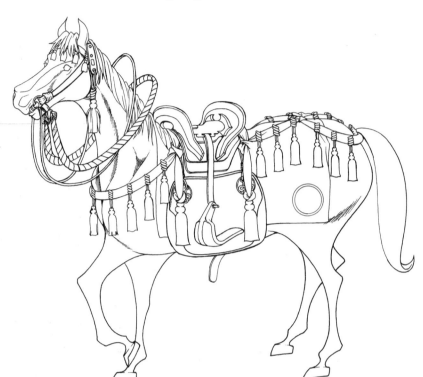

Harness
Saddle structure
All the parts on the right come together
to form one piece.

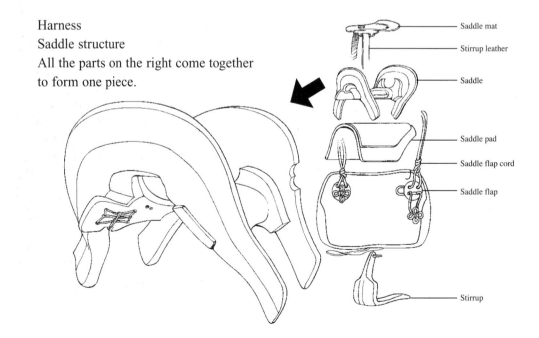

Saddle mat

Stirrup leather

Saddle

Saddle pad

Saddle flap cord

Saddle flap

Stirrup

Background, samurai residence, temples and shrines

The layout of a town during the Edo period-the castle is located in the center

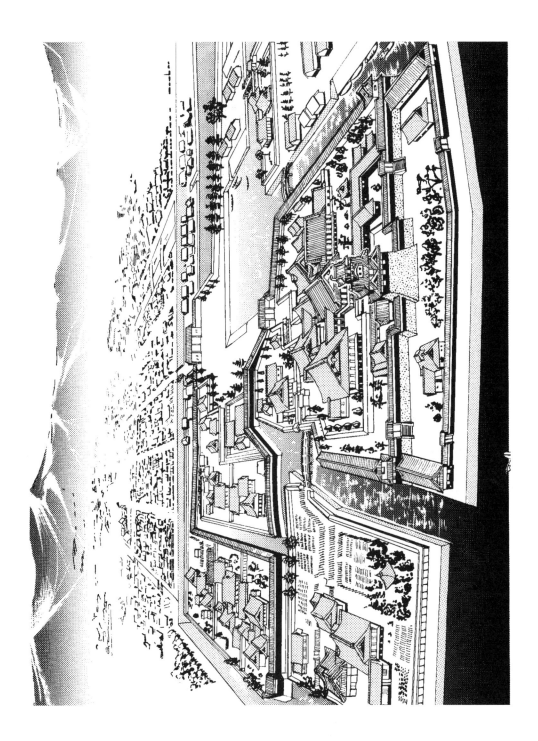

Background, samurai residence, temples and shrines

Samurai residence

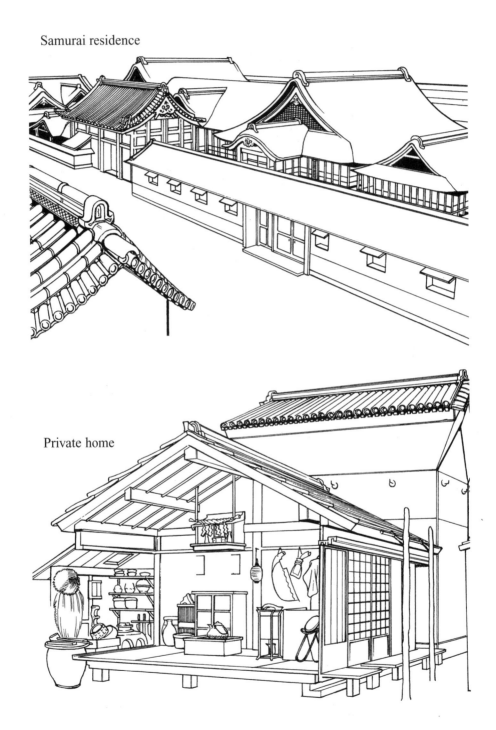

Private home

Grounds of a shrine

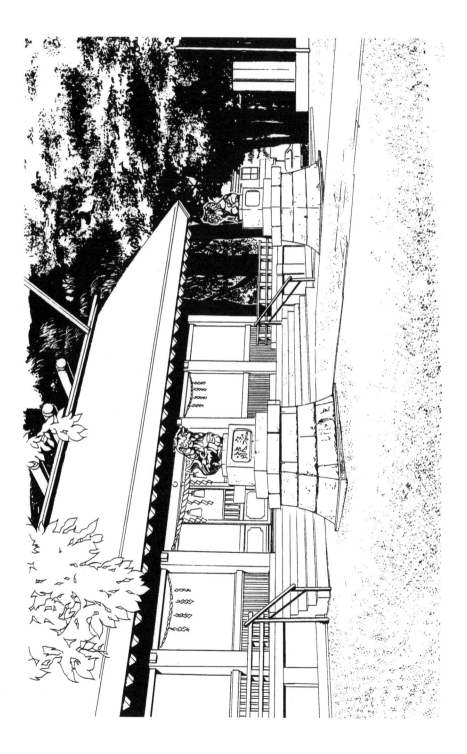

Background, samurai residence, temples and shrines

A bird's eye view of a castle

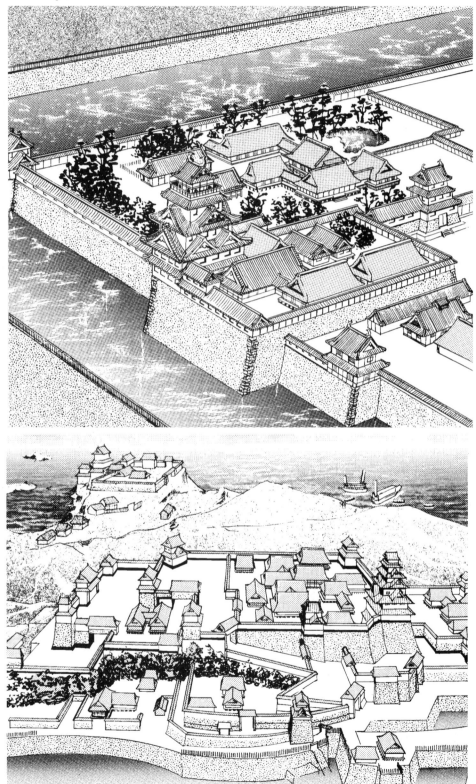

Background, samurai residence, temples and shrines

Japanese castles can come in a variety of shapes and sizes. The ones here are in the more traditional Japanese style, with a classic design to them. These types of castles would double as the residence of feudal lords and as a military outpost - often the most important military location in the area. A well built castle's defenses were formidable - the surrounding moat served to halt the progress of attackers.

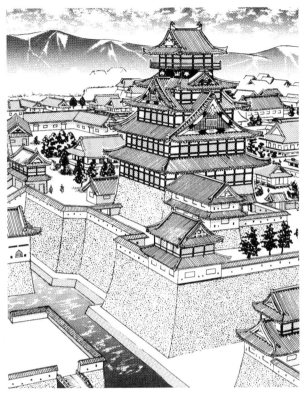

Fushimi Castle

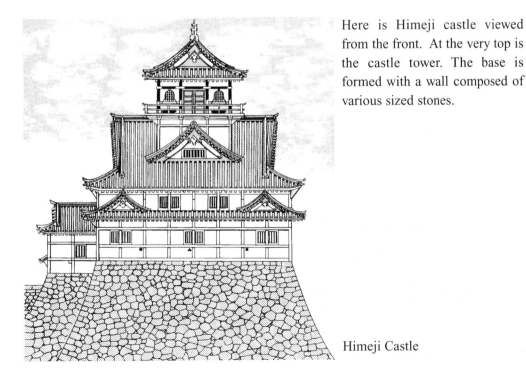

Here is Himeji castle viewed from the front. At the very top is the castle tower. The base is formed with a wall composed of various sized stones.

Himeji Castle

Background, samurai residence, temples and shrines

Osaka Castle

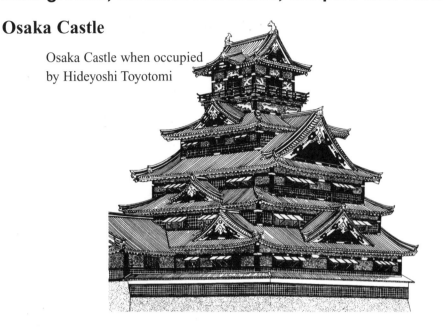

Osaka Castle when occupied
by Hideyoshi Toyotomi

Osaka Castle tower is the third in a line that stretches back to Hideyoshi Toyotomi. He ordered the first tower to be built, and it is thought to have been completed in 1585. It burnt down, however, in 1615 during Osaka Natsu-no-Jin (summer siege of Osaka Castle). A few years after that, the tower was reconstructed over an eleven year period by Ieyasu Tokugawa, only to be burnt down again 39 years later in the reign of the 4th Tokugawa Shogun, Ietsuna. During the Meiji Restoration the tower was again scorched and Osaka Castle remained towerless until the Showa Period (1926). In commemoration of the Showa Emperor's coronation the city drew up reconstruction plans in 1928. Due to the worldwide depression at the time, most of the funds for the rebuilding came from Osaka's citizens. The tower you see today is made of ferroconcrete.

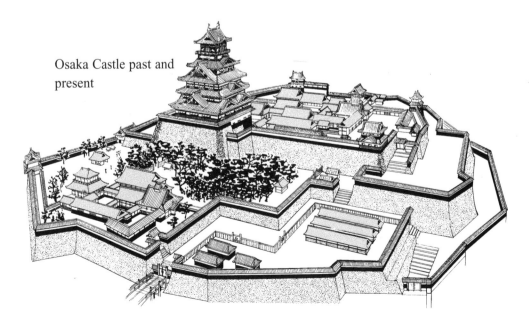

Osaka Castle past and
present

Chapter 5
Weapons, personal effects and background
Background, samurai residence, temples and shrines

Clothes worn by princesses and townsfolk

Princess

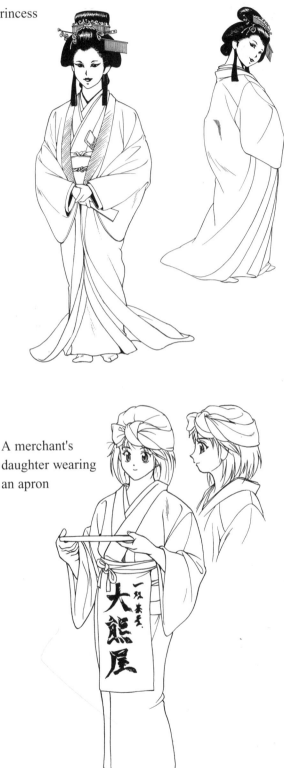

Girls born to the homes of nobility or the ruling Shogun of the time were called princesses. A careful look at historical records, however, shows that due to the hereditary system most of their names have faded into history.

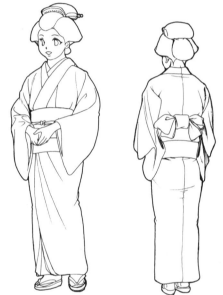

A merchant's daughter wearing an apron

The daughter of a lackey normally wears the sash in a simple bow called bunko or chocho musubi.

Other characters

Doshin-policemen (1)

The Chinese characters for doshin originally meant agreement and cooperation; later it came to include a feudal lord's upper vassals who would carry out his orders. The doshin of the Edo period were mainly engaged in policing. With a short metal truncheon they would walk around town seeking and arresting.

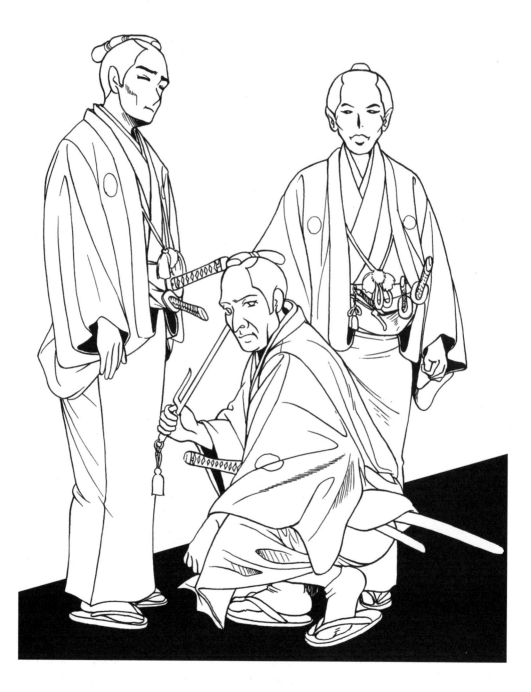

Doshin-policemen (2)

Featured to the left is a slightly smug-looking doshin. He has his family coat of arms on his chest, which appear on both sides of the haori.

Jitte-short metal truncheon
An essential item, which finds parallels in the modern day policeman's nightstick.

Chochin-paper lantern

Chochin are portable lamps used during the Edo period. Made from thin strips of bamboo and paper coated in oil, the lantern can be compressed like an accordion into a smaller shape. Inside is a placed candle and a wick soaked in oil which provides light when lit.

Other characters

Monk and priest of the Fuke sect

Soryo-monk

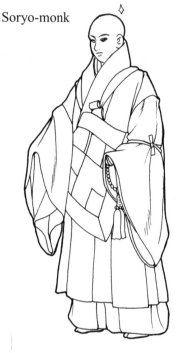

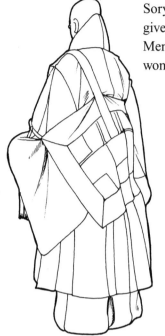

Soryo is the general name given to Buddhist priests. Men were called so and women were called ama.

Komuso-priest of the Fuke sect

Originating within Zen, the priests of the Fuke sect were known as a komuso. They were materially poor men who would travel from door-to-door playing the shakuhachi. During the Edo period, they wore deep straw baskets called tengai and carried wooden swords. They had permission to travel about the country leading an itinerant reli-gious life. However, midway through the Edo period the crimi-nals began disguising themselves as komuso and the Edo Shogun had to clamp down on their movement.

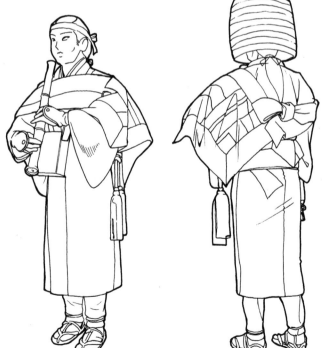

Villains

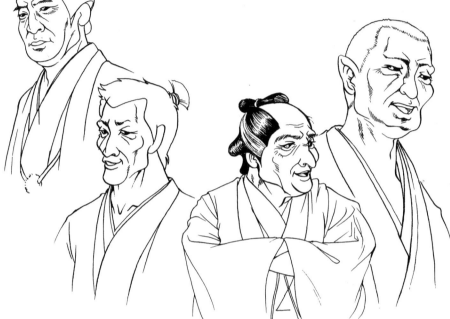

One secret to drawing shady-looking characters is to give them large nostrils, furrowed brows and drooping eyes. Making the pupils white and the rest of the eye black also enhance this effect. Essentially these types of characters should be drawn realistically as possible.

Zatoichi-the blind swordsman
Blind and dressed as a masseur, this master swordsman would wander from village to village. His neutral moral stance was unique. The cane he carried was fitted with a sword which he would use to dispatch his attackers with lightning speed. He is a fictional character.

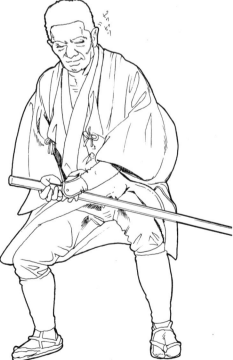

Weapons, personal effects and background

Chapter 5 | Other characters

The author

The author
Hidefumi Okuma

8th year graduate of Koike Kazuo's Gekiga Sonjuku School
Debuted with, *Sen no Rikyu-the real ruler?*
Hidefumi Okuma's skills and technique as a professional assistant have been highly rated
and over the years he has written a number of books focusing on techniques and back-
ground. Currently his work appears in two ongoing series. According to him, "It's hand to
mouth, but I get by!"

Co-illustrator
Hiroshi Tamawashi

Born: June 3rd, 1960
Lecturer at the International Animation Institute
Credited with training numerous animators he currently works in the video game industry.
Production supervisor for *Data East Corporations*, *Night Slashers*, *Wind Jammers*, *Skull
Fang*, *Magical Drop III* and *Outlaws of the Lost Dynasty*.

Daihei Tashiro

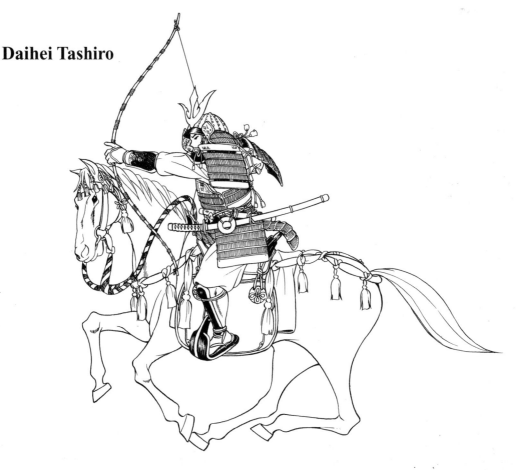

More!!! Let's Draw MANGA 漫画

Let's Draw Manga - Transforming Robots
By: Yasuhiro Nitta: PLEX
ISBN :1-56970-991-2
SRP: $19.95
Softcover w/ Dustjacket, 7 1/8" x 10 1/8"
Approx: 128 pages in B&W
English text, Digital Manga Publishing (DMP)
NORTH AMERICAN TERRITORY

Transforming Robots has been staple in anyone's life when watching cartoons, reading comic books or even playing video games. The way they magically transform and the complexity of their designs have captured the imagination of viewers for years.

People interested in drawing these transforming robots will find that this book is filled with all the useful and necessary information that one requires. Artists will learn from the pros about basic design history and cube transformations. Inside you will also find chapters dedicated to specific types of transforming robots. Like Sports Cars, Semi-trailers, Bulldozers, Tanks, Jet fighters, Dinosaurs and more. This book covers it all with lots of illustrations and easy to understand step by step descriptions. Step back and prepare to transform your drawings!

Let's Draw Manga - Astro Boy
By: Tezuka Productions
ISBN :1-56970-992-0
SRP: $19.95
Softcover w/ Dustjacket, 7 1/8" x 10 1/8"
Approx: 128 pages in B&W
English text, Digital Manga Publishing (DMP)
NORTH AMERICAN TERRITORY

Astro Boy, the most recognized classic Japanese animated character, is making a large comeback in Japan and across America. WB Kid's is planning to air the new *Astro Boy* series later this fall and Columbia pictures is releasing a CG animated movie of Astro Boy shortly after. Now is a great time to stock up on Japan's most lovable robot.

This volume of the *Let's Draw Manga* series will provide the readers with all the wonderful characteristics that makes Osamu Tezuka's Astro Boy one of the greatest animated characters ever. Astro Boy's popularity and global appeal in the animation world are rivaled only by Walt Disney's Micky Mouse, both of whom are major power houses in the cartoon business! Inside, you will find pages fully explaining and illustrating all the different views, proportions and attributes of Astro Boy, never reavealed in such fine detail in the past, thereby making this book a must-have for kids and teens alike.

Let's Draw Manga - Sexy Gals
By: Heisuke Shimohara
ISBN : 1-56970-989-0
SRP: $19.95
Softcover w/ Dustjacket, 7 1/8" x 10 1/8"
Approx: 118 pages in B&W
English text, Digital Manga Publishing (DMP)
NORTH AMERICAN TERRITORY

Sexy and appealing *Let's Draw Manga- Sexy Gals*, helps to deliver that romantic element to a person's work that may be missing. Drawing beautiful women and men in seductive poses can be one of the trickiest and most problematic for an artist to depict sincerely. Long flowing hair, body proportions, poses and clothing that hang by a thread are just some of the attributes that will help to lend to the physical attractiveness and prowl-ness of your drawings. Miniskirts and open shirts with a touch of soft and heavy petting. *Let's draw Manga- Sexy Gals* is a fun and flirtatious book with a provocative look at suggestive comics.